THE
AIRBRUSH
ARTIST'S
HANDBOOK

Fred Dell with
Andy Charlesworth

RUNNING PRESS
PHILADELPHIA, PENNSYLVANIA

Library of Congress Cataloging-in-Publication Data
Dell, Fred
 The airbrush artist's handbook.
 Includes index.
 1. Airbrush art. 2. Artists' materials. 3. Artists' tools.
 4. Airbrush art — Marketing.
I. Charlesworth, Andy. II. Title
NC915.A35D44 1986 761.4'94 86-10062
ISBN 0-89471-466-X (Cloth)

Published by Running Press Book Publishers
125 South Twenty-Second Street
Philadelphia, Pennsylvania 19103.
This book can be ordered by mail from the publisher.
Please include $1.75 for postage.
But try your bookstore first.

Typeset by Facsimile Ltd and
Lynne Shippam, QV Typesetting Ltd
Manufactured in Hong Kong by Regent Publishing Ltd
Printed by Leefung-Asco Printers Ltd, Hong Kong

Senior Editor Sandy Shepherd
Art Editor Moira Clinch

Designers Vincent Murphy, Tom Deas

Photographers Jon Wyand, Paul Forrester

Paste-up Penny Dawes, Mick Hill

Art Director Alastair Campbell
Editorial Director Jim Miles

CONTENTS

FOREWORD

Every airbrush artist, whether a professional artist or a hobbyist, needs to be able to rely on his or her airbrush and know that it will not fail. If it breaks down in the middle of an important job, it may be very difficult to find an airbrush technician who can repair it on the spot. Some airbrushes *are* quite complicated and consist of a lot of small components, but most can be dismantled and repaired without a great deal of difficulty.

A fully-fledged airbrush repairer would have sets of special tools to make it easy to work on any airbrush ever produced, but the amateur can do most of the important jobs with ordinary household tools and a few more specialized implements.

This manual shows you how to carry out routine maintenance jobs on your airbrush and how to dismantle it completely for cleaning and repair purposes. All the main types of airbrush are covered here — sometimes an airbrush can appear with a different name on the handle, so if your particular airbrush is not listed, look for the closest type in the step-by-step dismantling sequences.

Whether you are an experienced airbrush artist or a novice, the sections on assembling compatible systems of airbrushes and compressors, and on choosing suitable types of paints will help you to avoid problems. If the airbrush itself develops a fault, you will be able to identify the cause from the fault-finding chart and then fix the fault by going through the strip-down sequence. Putting the airbrush back together again is usually just a matter of reversing the sequence but, where there are differences, any particular points that are important for reassembly have been covered.

Most routine jobs on the airbrush are straightforward and can be carried out without any risk of damaging the airbrush. Even if you find a fault that you cannot cure yourself, you will be able to discuss the repair with a professional airbrush technician and make sure that the correct repair is carried out without paying for unnecessary work.

Treat your airbrush with care and respect and it should give you years of good service as well as being an enjoyable hobby or a profitable investment.

Andy Charlesworth

Andy Charlesworth
(Author)

Fred Dell
(Technical Consultant)

1
THE TOOLKIT

Wrenches/Screwdrivers/Pliers/Pin
vices/Magnifiers/Handy miscellany/
Lubricants/Greases/Solvents/
Aerosols/Abrasives/Jointing compound

Your airbrush is an expensive piece of equipment and needs maintenance to keep it working well. It therefore makes sense for you to invest in a basic toolkit. Most of these tools are not expensive and will pay for themselves when you have carried out a few service and repair jobs yourself, not to mention the savings you will make if you can finish an important artwork on time, rather than lose the contract because your airbrush has let you down.

There are a number of special tools which are supplied by airbrush manufacturers to their service agents. If you are going to do a lot of work on airbrushes it may be worth investing in such a set of service tools, but for the average owner their expense will hardly be justified by the time that they save.

In addition to having the actual tools of repair, it is important to have suitable conditions for working on your airbrush. One of the biggest hazards in airbrush maintenance is losing small parts such as washers and screws. To reduce this possibility always work at a table or bench where there is plenty of light. The best way to avoid losing any part of the airbrush is to dismantle it over a fairly large and shallow, but contained area, such as a cookie jar lid, so that any small components can drop into it and be retrieved easily.

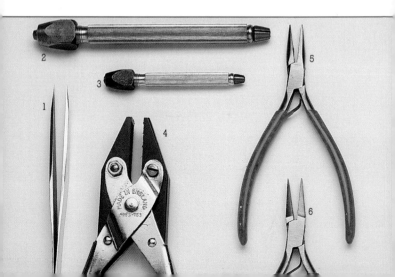

Wrenches

Some airbrushes come complete with simple service tools such as small wrenches to fit the nozzles. They are made specifically for particular airbrushes, and if this is the case with your airbrush, do not be tempted to use a longer wrench because this will enable you to apply too much force to the nozzle, which may damage it.

Screwdrivers

A small electrician's screwdriver will cope with many of the screws that are used in airbrush construction but, for the smallest of screws, watchmaker's screwdrivers are ideal. These have small blades and are available in sets of graded sizes. Apart from their small size, watchmaker's screwdrivers have the advantage that they can be controlled very accurately — the pad at the opposite end to the blade is pivoted so that you can apply pressure to the screwdriver with your index finger while the blade is rotated between your thumb and middle finger.

It is not advisable to use makeshift tools such as penknives when dealing with small screws because you may well damage the screwhead and let yourself in for a time-consuming and costly repair.

Pliers

Another versatile tool to have in the kit is a pair of pliers. The jaws of pliers are made of hard steel that can bite into the airbrush, so it is best to wrap them in a soft material with some "give", which will not damage the airbrush. Plastic garden hosepipe can be forced over the jaws of the pliers for this purpose — make sure that you choose a size of hose that gives a tight fit or it may slip around the metal instead of gripping it. Alternatively, you can wrap the jaws with a thin sheet of soft metal like aluminum, lead or copper. Again, fit the metal tightly around the jaws to prevent it from slipping.

A pair of tweezers with pointed ends is also often useful in airbrush work because there are a number of parts inside airbrushes, such as airvalves and nozzle washers, that can be difficult to extract. Tweez-

The tools shown (**below**) will enable you to carry out most of the ordinary jobs which you are likely to come across on the airbrush. (**1**) a pair of fine tweezers; (**2**) a large pin vice for holding nozzles; (**3**) a small pin vice for working on needles; (**4**) parallel-action pliers; (**5**) round-nosed pliers; (**6**) flat-nosed pliers; (**7**) an orange stick and a supply of cotton balls; (**8**) a stick of clock repairer's pegwood; (**9**) and (**10**) adjustable wrenches; (**11**) a jeweler's hammer; and (**12-16**) a set of watchmaker's screwdrivers.

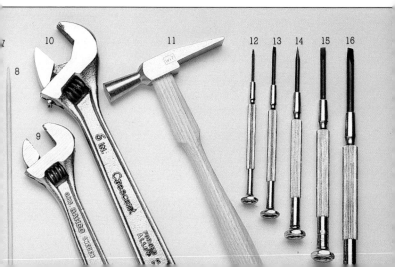

ers are just small enough to get at these parts and just large enough to be controllable.

Pin vice

Another useful tool, that will soon repay its purchase price, is a pin vice. This tool has jaws, rather like the chuck of a drill, that can be tightened by a collar to grip circular objects. Ideally, you should equip yourself with a small pin vice for holding the needle and a larger one for work on the nozzle. The great advantage of the pin vice is that it can hold small and delicate components securely so that you can work without fumbling on fiddly jobs like nozzle cleaning.

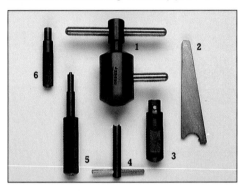

Specialized tools are worth having if you want to do a lot of jobs on your airbrush. (**1**) an air valve removal tool; (**2**) an aluminum body removal tool for the DeVilbiss Sprite; (**3**) a trigger link holding tool for the DeVilbiss Super 63; (**4**) diaphragm nut removal tool; (**5**) air valve washer insertion tool; (**6**) diaphragm insertion tool. The last three tools are designed for older models of the De Vilbiss Super 63.

Magnifiers

A lot of the more delicate jobs on airbrushes involve working with tiny components or making delicate adjustments to easily-damaged parts like needles. In view of the possible eye strain, and the risk of either damage or not completing the repair correctly, it is often easier to view the job under magnification. The ideal way of achieving this is to wear a headband magnifier, but you can manage almost as well with a jeweler's eyeglass. At first it feels unfamiliar to hold the eyeglass in your eye, but with practice it will become no hardship to use it for a few minutes at a time. Another possible substitute is the whole-page magnifer that is used for reading by people with failing sight, but this too introduces the problem of having to keep the airbrush, tools and your hands behind the magnifying screen.

Handy items

A number of other items will make your workshop area much more usable. A box of paper tissues or a roll of paper towels will always come in useful for a hundred-and-one cleaning and wiping jobs. In addition, a metal garbage can should be near at hand so that used tissues do not accumulate. Do not use an open-weave basket! Even experienced technicians sometimes accidentally throw away a small component — a metal can will hold it safe until you retrieve it.

An absolutely flat, hard surface is needed for straightening bent needles. The ideal surface is probably a piece of float glass but if you cannot get one, a thick sheet of metal will serve you just as well.

Chemicals and cleaners

Just as it is important to have the right tools to hand in order to make working on the airbrush a streamlined procedure, it is helpful to have a selection of chemicals and cleaners in the workshop. It is a good idea to label all bottles and containers clearly to avoid confusion, and also to keep all the bottles well out of the reach of inquisitive children.

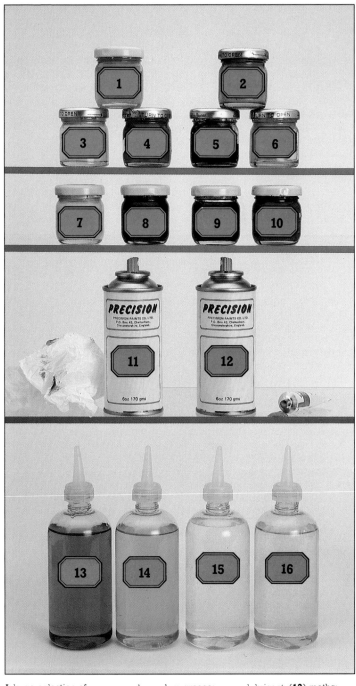

A large selection of greases and solvents is always handy if you use your airbrush a lot for varied work. (**Above**), the selection includes: (**1**) HMP grease; (**2**) boss white; (**3**) white polishing paste; (**4**) carborundum grease; (**5**) graphite grease; (**6**) petroleum grease; (**7**) Brasso; (**8**) assembling lubricant; (**9**) Teflon grease; (**10**) jointing compound; (**11**) aerosol airbrush cleaner; (**12**) aerosol airbrush lubricant; (**13**) meths; (**14**) isopropyl alcohol; (**15**) clean water; (**16**) brake fluid.

Aerosol lubricant

One of the most useful aids in the workshop is an aerosol lubricant. This product has various capabilities — it acts both as a lubricant and as a penetrating oil for freeing tight nuts and screws. Make sure that you do not loose the plastic tube that fits into the aerosol's nozzle to direct the spray accurately because a lot of airbrush lubrication jobs need a controlled spray of lubricant in exactly the right place.

A squirt of lubricant will often release a reluctant screw, but a more specialized releasing agent may be needed in extreme cases. Allow time for the releasing agent to seep into the thread before trying to undo the screw — if this does not work you may have to consider paying for a professional repair.

Some parts of the airbrush, such as the needle return spring, can suffer from rust that will prevent it from working properly. There are a number of proprietary products on the market that remove or prevent rust. The most useful for airbrush work are those that are sold in clear liquid form, rather than the types that are also primers and are more suited for use on car bodies.

Greases

There is a great variety of greases available for all sorts of specialized uses but just two kinds will cover all the applications involved in airbrush work. Only the smallest quantities are needed for airbrush maintenance, and you would probably never use up an entire can of grease. If your local garage will fill up a small jar of grease, that will be all you need. Ask for HMP (high melting point) grease and also for a copper-based grease. There are a number of black lithium-based greases but, although these are excellent lubricants, they have a remarkable ability for getting everywhere and you run a great risk of spoiling your clothes or even ruining an important artwork irrevocably.

Solvents

A lot of the jobs on airbrushes involve removing solidified color that has clogged up passages inside the airbrush or accumulated around movable parts. Methyl hydrate will dissolve many of the common types of color. Keep a small glass jar of it handy so that you can drop the part that needs cleaning into it. Leave it to soak and then lift it out again with tweezers. If the accumulated color is reluctant to dissolve, an overnight soaking in brake fluid should do the trick.

Compressed air spray

Another useful piece of equipment for blowing away specks of dirt and for cleaning inaccessible passages is a compressed air spray, such as camera shops sell for cleaning lenses.

Abrasives

One of the enemies of smooth-running airbrush parts is the gradual build-up of corrosion on metal components. A lightly abrasive polish, such as Brasso, is useful for removing any surface film so that the airbrush will work smoothly, as well as giving it an attractive newly-polished appearance.

Jointing compound

Lastly, a jointing compound is useful for making sure that you achieve an airtight seal between closely fitting parts. A small tube of jointing compound will probably see you through a lifetime of airbrush maintenance.

HOW AIRBRUSHES WORK

External and internal atomization/
Single-action/Double-action/
Independent double-action/Siphon
feed/Gravity feed/Felt-tip fed
airbrush/Paasche Turbo/Air eraser/
Chart of airbrush types

The basic principle that makes an airbrush work is that when a stream of gas is made to go faster by being forced through a narrow passage, its pressure drops. If a tube, feeding from a reservoir of liquid, is positioned at the point where the flow of gas is fastest, the drop in pressure will cause some of the liquid to be drawn into the stream of gas. As the stream of compressed air is accelerated by being forced through the nozzle, its speed is so great that the paint, which is drawn into the air stream in small quantities, atomizes to form a uniform, fine spray.

In an airbrush, the gas may be compressed air, pressurized carbon dioxide or a special gas such as Freon, and the liquid can be paint, ink or one of a number of other coloring agents. The passages in the airbrush, through which the air and the paint flow, are machined accurately so that the amount of each in the spray can be controlled precisely.

External and internal atomization
Some basic airbrushes work by external atomization — that is to say, the air stream is blown across the paint feed at the very tip of the airbrush. This means that the mixing (or atomization) is not complete, resulting in a less than perfectly even spray of paint. Somewhat more sophisticated is the internal atomization principle. Airbrushes using this feature produce a more even result because the paint and air are mixed inside the nozzle and so the atomizing of the paint takes place under more controlled conditions. Internal atomization is used in all but the most basic airbrushes.

Some control is needed over the amount of paint that mixes with the air stream. Airbrushes have a tapered needle that fits into a nozzle through which the spray emerges. The amount of space between the needle and the nozzle controls the quantity of paint that mixes with the compressed air. The needle and the nozzle are matched carefully so that the flow of paint and air past the needle and through the nozzle is controlled exactly.

There are three basic designs of airbrush: single-action; double-action; and independent double-action.

Single-action
With this design, the control button (**1**) on top of the airbrush is pressed to allow air to flow. However, the artist cannot control the ratio of paint to air with the button, nor the spray pattern. The only way of

controlling the pattern of paint on the paper while spraying is by moving the airbrush away from the paper, to give a broader area of spray, or nearer to the paper, to reduce the area.

Some models of single-action airbrushes have a control ring to vary the ratio of paint to air, but this needs to be pre-set before you begin to spray. Other single-action types, which use external atomization, allow some control over the spray by moving the paint feed nearer to or farther from the air nozzle to vary the amount of paint that is drawn up and mixed with the air.

Double-action

More versatile than the single-action airbrush is the fixed, double-action variety. A lever (**1**) on this airbrush controls the flow of both air and paint, but not the ratio of one to the other. This lever is usually mounted on top of the airbrush and is adjusted by a screw (**2**). The lever passes down into the body of the airbrush and is pressed down to release both paint and air. The first fraction of travel opens the air valve (**3**), which releases the air. The rest of the travel retracts the needle (**4**) from the nozzle (**5**), which allows the paint to flow into the air stream. It is possible to use the first fraction of the travel of the lever to blow air through the airbrush without releasing any paint. This means that it is possible to begin spraying by feeding in the paint gradually; it also means that you can finish a piece of work by reducing the paint flow to nothing before you lift the airbrush away from the work.

Independent double-action

This type of airbrush gives the artist the greatest control. Its lever (**1**) can be pressed down to control the air flow, and pulled back to vary the supply of paint. The ratio of paint to air can therefore be altered.

With independent double-action, you can spray pure air at full speed, and then feed in the color in small quantities to achieve delicate effects. Another advantage is that it is easier to keep the airbrush passages clear by lifting the airbrush away from the work and then pressing the lever to give a blast of air to blow away any obstructions.

The operation of this lever needs extremely sensitive control — most models are therefore fitted with a cam ring (**2**) or adjustable screw that allows the lever to be fixed at a desirable point to maintain a constant flow of paint and air.

Siphon feed

You can choose between two different ways of holding the color that is fed into an airbrush. Siphon feed airbrushes have a cup that screws to the side or to the underside of the airbrush, and holds the color. The cup often has a large capacity, which makes it suitable for spraying large areas in the same color. Also, paint cups are available that are already filled with different colors to make color changes quick and easy. Nonetheless, siphon feed airbrushes are often made rather cumbersome by the bulk of the cup, and so it can be difficult to use this type when close work is required or when especially fine control is needed.

Gravity feed

The alternative to siphon feed is gravity feed. Gravity-fed airbrushes have a bowl or cup mounted permanently on the body, or a recess formed in the body of the airbrush itself. In general, gravity-fed airbrushes hold a smaller quantity of paint than their siphon-fed counterparts do, but their cups can be topped up easily. Most artists find that

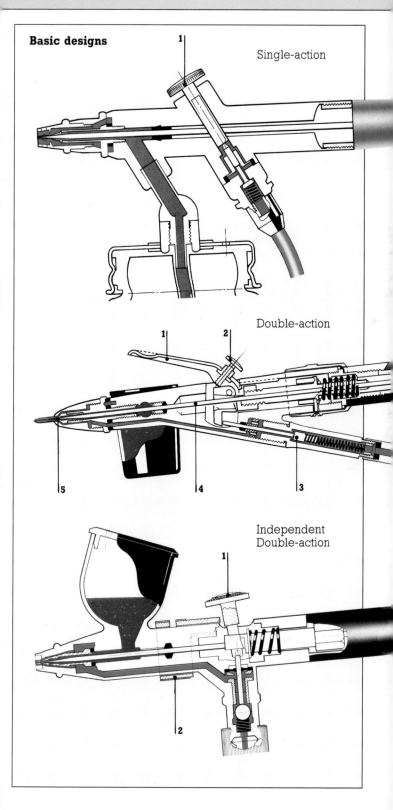

Basic designs

Single-action

Double-action

Independent
Double-action

the lighter weight and smaller bulk of the gravity feed designs make them more maneuverable and better for accurate detailed work.

Felt-tip fed airbrushes

There are two types of airbrush that do not fall into the general designs — one is extremely simple whereas the other is much more complicated. The simpler exception to the rule does not use paint that is mixed and poured in by the artist. Instead, it draws its color from a large felt-tip pen that is mounted in a holder so that the felt is adjacent to the air stream that blows through the nozzle of the airbrush. As in the conventional siphon feed system, color is drawn up and mixed with the air stream to form a fine spray. This type of airbrush is rather crude in the results that it can produce but, on the other hand, it makes changes of color very simple — you just pull out one felt-tip pen and push in another.

Paasche Turbo

The other, more complicated airbrush is the Paasche Turbo. As well as working on a different principle, the Turbo even looks unlike any other airbrush. It still uses compressed air to produce a spray of paint, but some of the compressed air flows through a turbine. This turbine is linked to a needle that moves backward and forward, according to the speed of the turbine, alternately into the paint feed and into the air stream. Each time the needle meets the paint feed it picks up a tiny amount of paint that then moves into the air stream to be turned into an atomized spray. This whole cycle occurs at a speed of about 20,000 rpm. The artist can control the speed of the turbine finely so that when

TYPES OF AIRBRUSH

There is a very wide range of airbrushes on the market, each with different capabilities. Choosing the right one for your needs depends on how much you want to spend, what sort of work you will be doing and what sort of color you want to spray. The following chart

AIRBRUSH	TYPE OF AIRBRUSH Single-action	Double-action	Double-action turbine	External mix opposed nozzle
Badger 350-F				•
350-M				•
350-H				•
200 Ex	•			
100 GXF		•		
100 XF		•		
100 IL		•		
100 LGXF		•		

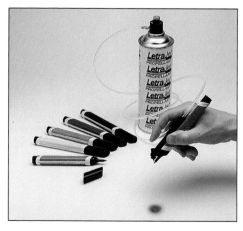

This simple airbrush (**left**) is driven by an aerosol can and draws its paint from a large felt-tipped marker pen. It does not have the sophistication of a fully-fledged airbrush but allows quick and easy color changes.

the turbine is running slowly it can produce a very thin line.

Air eraser

Lastly, there is the air eraser, which uses the normal airbrush principle, but sprays abrasive particles rather than paint. As well as being able to erase mistakes, it can be used to introduce shading into a piece of artwork by cutting back part of the surface. Some artists use air erasers for engraving glass because the spray of abrasive particles removes the polished surface of the glass.

shows most of the airbrushes that are available at the moment. You should be able to find one that fits your requirements. If your needs are very wide-ranging, it may be necessary to have more than one airbrush to cater for every occasion.

AIRBRUSH	TYPE OF COLOUR FEED		
	Gravity	Siphon	Side cup siphon
Badger 350-F		•	
350-M		•	
350-H		•	
200 Ex		•	
100 GXF	•		
100 XF			•
100 IL			•
100 LGXF	•		

Types of Airbrush Chart
Continued

AIRBRUSH	TYPE OF AIRBRUSH Single-action	Double-action	Double-action turbine	External mix opposed nozzle	
Badger 100 LGIL		●			
100 LGHD		●			
150 XF		●			
150 IL		●			
150 HD		●			
400 Touch-Up Gun	●				
Conopois	●				
De Vilbiss Super 63 A		●			
Super 63 E		●			
Sprite		●			
Sprite Major		●			
MP C-C	●				
MP 1-1	●				
MP 2-2	●				
MP 3-3	●				
Hohmi Y-3		●			
Iwata HP-A		●			
HP-B		●			
HP-C		●			
E-1		●			
E-2		●			
SB		●			
BC		●			
BE-1		●			

AIRBRUSH	TYPE OF COLOUR FEED Gravity	Siphon	Side cup siphon	
Badger 100 LGIL	●			
100 LGHD	●			
150 XF		●		
150 IL		●		
150 HD		●		
400 Touch-Up Gun		●		
Conopois			●	
De Vilbiss Super 63 A	●			
Super 63 E	●			
Sprite	●			
Sprite Major		●		
MP C-C	●			
MP 1-1	●			
MP 2-2	●			
MP 3-3	●			
Hohmi Y-3	●			
Iwata HP-A	●			
HP-B	●			
HP-C	●			
E-1	●			
E-2	●			
SB		●		
BC		●		
BE-1		●		

Types of Airbrush Chart
Continued

AIRBRUSH	TYPE OF AIRBRUSH Single-action	Double-action	Double-action turbine	External mix opposed nozzle	
Iwata BE-2		•			
Olympos HP 100 A		•			
HP 100 B		•			
SP-A		•			
SP-B		•			
SP-C		•			
Paasche F-1				•	
H-1				•	
H-3				•	
H-5				•	
VJR		•			
V-1		•			
VLS-1		•			
VLS-3		•			
VLS-5		•			
AB Turbo			•		
Rich AB-100		•			
AB-200		•			
AB-300		•			
Thayer & Chandler Model A		•			
Model AA		•			
Model C		•			
Model E	•				
Model G	•				

AIRBRUSH	TYPE OF COLOUR FEED Gravity	Siphon	Side cup siphon	
Iwata BE-2		•		
Olympos HP 100 A	•			
HP 100 B	•			
SP-A	•			
SP-B	•			
SP-C	•			
Paasche F-1		•		
H-1		•		
H-3		•		
H-5		•		
VJR	•			
V-1			•	
VLS-1		•		
VLS-3		•		
VLS-5		•		
AB Turbo			•	
Rich AB-100	•			
AB-200	•			
AB-300	•			
Thayer & Chandler Model A			•	
Model AA			•	
Model C		•		
Model E		•		
Model G		•		

3
AIRBRUSH MAINTENANCE

Needle/Nozzle/Diaphragm/Air valve/
Return spring/Needle packing gaskets/
Trigger pin/Fault-finding chart

Careful maintenance of the airbrush is essential if it is to keep working at the peak of its capabilities. However, correct use will make sure that major work on the airbrush is kept to a minimum.

One of the most important factors that affects the airbrush's reliability is cleanliness. The tiny passages inside the airbrush can become blocked easily by dried paint if all the color is not blown through after the airbrush has been used.

If there is still a usable amount of color in the color cup or reservoir when you have finished spraying, pour it or brush it back into the bottle and then spray onto a spare piece of paper until the color has gone and the spray consists of pure air. Then spray with clean water, or an appropriate solvent, onto white paper until the spray is colorless.

Some types of paint can dry remarkably quickly, so you should always wash through the airbrush every time you finish spraying. If the paint is allowed to dry inside the airbrush you may be lucky and find that spraying water through it will dissolve the paint, but if this does not work you will need to try a solvent. (Solvents are classified according to the paints they will dissolve.) If a special solvent cannot dissolve the paint and restore the smooth working of the airbrush, you will have to strip the airbrush down and clean away any blockages.

Needle maintenance

Cleaning the airbrush needle is part of routine maintenance – ideally, you should clean the needle after every day's work. It is also a good idea to check that the tapered end of the needle is still straight because the quality and accuracy of the spray pattern will deteriorate if the needle is bent.

First unscrew the handle of the airbrush so that you can reach the needle-locking nut. Then loosen the locking nut until the needle is free to move. Pull the needle backward gently, making sure that you do not catch its pointed tip on the locking nut as it slides through. You can remove any small specks that may have gathered on the needle, on the palm of your hand. Pull the needle slowly across your hand as you rotate it. It is best not to wipe the needle with a cloth or a tissue because you may well leave tiny specks of material on the needle that may block up the airbrush.

To check whether the needle point is straight, examine it through a magnifying glass. The point of the needle is so fine that it is very easily damaged by rough handling. If the point is bent back on itself

like a crochet hook it is probably past saving and you will need to fit a new one. However, if it is slightly bent or kinked, you can probably straighten it by rolling it gently with your finger on a perfectly flat, hard surface such as a piece of glass or a polished piece of metal.

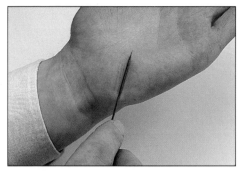

The point of a needle is so delicate that it can easily become bent. As long as the point is not too crooked, you can straighten it by drawing it across the fleshy part of your hand (**left**). Rotate the needle gently as you pull it across your hand, being careful not to exert too much force on the fine point of the needle.

A block of glass forms the ideal flat surface for straightening the tip of a needle, but a perfectly flat metal surface will do the job (**right**). Lay the needle down flat on the surface and then slowly raise the tail of the needle until the tapered tip of the needle is parallel with the surface of the glass.

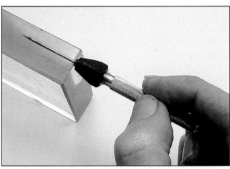

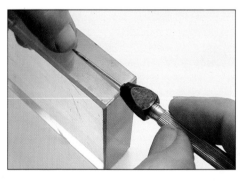

When the tip is parallel with the surface, gently anchor the tip with your fingernail, and then draw the needle slowly across the glass, turning it as you do so, (**left**). As the tip passes under your fingernail, any small irregularities in the needle will be straightened out and the needle should be ready for service again.

Nozzle maintenance

After the needle, the nozzle is the component that needs the most frequent cleaning and maintenance. A nozzle that is partly blocked will produce an erratic spray pattern — routine maintenance is therefore essential.

The term "nozzle" is often used rather loosely to mean the whole assembly that consists of the nozzle, nozzle guard and air cap. I am referring here to the nozzle itself but it is well worth checking and cleaning all the components at the same time.

First, withdraw the needle from the airbrush and put it in a safe place where its point cannot get damaged. Now unscrew the air cap assembly. There is often a knurled ring around the air cap that makes it easy to grip with pliers. If the nozzle guard and air cap have come off as one unit, unscrew the one from the other so that they can both be

cleaned easily. If the small slots in the·needle guard have become clogged with paint, clean them out by running your thumbnail into the slots and rubbing away the accumulated paint.

For those airbrushes that have screw nozzles, unscrew the nozzle preferably by using a small wrench. With the DeVilbiss airbrushes, check to see whether the small O-ring has come away with the nozzle. If it has not, it will still be in the airbrush body. Either shake it out or pry it out carefully with a pair of fine tweezers. Examine the O-ring for any signs of damage and fit a new one if it is not still in perfect condition.

If there is a build-up of paint on any of the components of the nozzle assembly, give them a few minutes' soaking in water or in a solvent designed to loosen the kind of paint you have been using. Then rinse the components in clean water and see whether any dried paint has been left behind.

A gentle way to clean inside the nozzle is to hold it in a pin viče, then make a twist from the corner of a paper tissue, dip the tissue in liquid metal polish and carefully rotate the twisted tissue inside the nozzle. Pull out the tissue frequently and look at the twisted end. You should find that, at first, it rapidly takes the color of the paint that is causing the blockage, but as the blockage is cleared away, the tissue should come out cleaner until all the paint has been removed.

Another way of cleaning the nozzle is to use a nozzle reamer to cut away any obstructions in the nozzle. This implement is available for Paasche, Badger and Thayer and Chandler airbrushes only, but you can use it on other models. However, this method is fraught with danger because there is a good chance that you will distort or split the nozzle so that the airbrush cannot spray accurately.

While the nozzle assembly is in pieces, examine the parts for wear or damage. If all seems well, reassemble the nozzle (if you have a DeVilbiss, do not forget to put back the O-ring), refit the needle and test the airbrush to check that it is working properly.

A twist of absorbent cotton wrapped around an orange stick and dipped in metal polish will clean off most deposits of paint (**above**). Keep polishing until no trace of paint appears on the cotton ball.

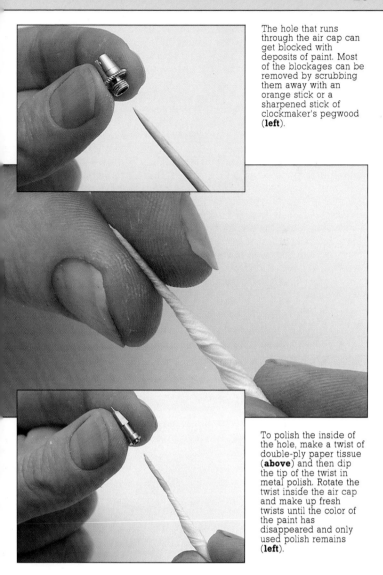

The hole that runs through the air cap can get blocked with deposits of paint. Most of the blockages can be removed by scrubbing them away with an orange stick or a sharpened stick of clockmaker's pegwood (**left**).

To polish the inside of the hole, make a twist of double-ply paper tissue (**above**) and then dip the tip of the twist in metal polish. Rotate the twist inside the air cap and make up fresh twists until the color of the paint has disappeared and only used polish remains (**left**).

Diaphragm maintenance

Some models of airbrush, notably the DeVilbiss Super 63, are fitted with a diaphragm that controls the flow of air through the airbrush when the trigger is pressed. The flexible part of the diaphragm is made from vinyl in models made before 1980. After this date it is a molded rubber and metal assembly. You will learn that all is not well with the diaphragm when air leaks up through the trigger or nozzle when the airbrush is turned off.

To get at the diaphragm, you should first take off the air valve assembly. This lies immediately above the screw thread where the air hose fastens on. To remove the air valve assembly, use a pair of pliers that have their jaws protected by soft metal or by lengths of plastic hose. Grip the air valve housing firmly and turn it anti-clockwise. Once it starts to move you can unscrew it all the way with your fingers.

When the air valve housing is detached from the airbrush, you will

be able to see the diaphragm nut that holds the diaphragm in place in the body of the airbrush. This nut has three equally spaced holes (in pre-1980 models only). The official service tool has three prongs that fit into these holes but you should be able to loosen it by using needle-nosed pliers.

Take great care not to let the points of the pliers slip on the nut or else you may damage the nut irreversibly and let yourself in for a much larger bill. If the nut does not shift immediately, try the pliers in a different pair of holes, working around steadily until you feel the nut begin to turn.

When you have taken out the diaphragm nut, you will be able to pull out the diaphragm itself with a pair of flat-nosed pliers. Examine the flexible surface of the diaphragm for any signs of cracking or distortion and fit a new diaphragm if the old one is not in perfect condition.

Fitting the new diaphragm into place can be a tricky business because it needs to be fitted with its pin absolutely vertical if it is going to do its job properly. Hold the pin of the diaphragm with flat-nosed pliers and push the head of the diaphragm into place. Then remove the pliers and check by eye that the diaphragm pin is exactly central in its housing. If it is not, pull out the diaphragm and try again — this is easier than trying to force it over to one side.

When the diaphragm is centralized, refit the diaphragm nut, tightening it up with the points of your pliers, then reattach the air valve assembly. Make sure that the new diaphragm is working properly by connecting the air hose and checking that there are no leaks of air coming up through the trigger or nozzle.

The special tool for removing the diaphragm nut fits exactly into the three holes on the nut and makes removing it very straightforward (**left**).

If you do not have the special three-pronged tool, fine-pointed tweezers can be used instead to remove the diaphragm nut. Engage the points of the tweezers with two of the holes and then unscrew the nut (**left**).

Air valve maintenance

You may experience problems with the air valve, which is operated by the trigger to control the flow of air through the airbrush. When the air valve is faulty you may get no air flow at all, or else air may leak through the nozzle or the trigger when the airbrush is turned off.

The air valve assembly is fitted into the body of the airbrush just

above the point where the air hose connects. Before you start to dismantle the air valve assembly, bear in mind that there is a spring inside. The assembly may fly apart when you have opened it up, and delicacy is therefore needed.

If the whole air valve assembly can be removed from your airbrush as one unit, loosen it with a pair of pliers and unscrew it from the airbrush. Then undo the air valve spring retainer, using either a screwdriver or a hexagonal key, according to the type of airbrush you have, and take out the retainer carefully. Lay out the components inside the air valve assembly in the order of removal so that you can refit them in the right order.

If the spring does not fall out of the housing, catch hold of the end with pliers or tweezers and turn the spring to and fro gently until it comes free, then pull it out of the housing. Shake out the air valve pin — if it does not fall out, either pull it out with tweezers or push it through from above using the blunt end of an airbrush needle. You will probably need to use fine-pointed tweezers to remove the air valve washer, if one is fitted to your airbrush. This washer sits at the top of the air valve housing, next to the main body of the airbrush. In other designs, the washer fits around the air valve pin. Check that the washer is not cracked or torn, and fit a new one if necessary. When the washer fits around the air valve pin, you can roll it off the sharp end of the pin with tweezers.

Clean all the components of the air valve assembly to remove all traces of corrosion or paint. If it was difficult to get out the spring, check that there is no corrosion inside the air valve housing or on the spring itself. If you find any corrosion, use a drop of rust remover and rub away the corrosion with an orange stick. Then wash the components thoroughly with water and let them dry completely before you reassemble them.

You can check whether the air valve is sealing correctly by blowing through it. Put the air intake in your mouth and blow. Then operate the trigger so that the air valve is opened and closed. You should find that the flow of air through the valve is cut off immediately when you release the trigger.

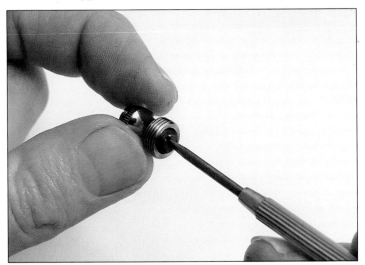

The screw on the end of the air valve assembly holds the spring in place. Loosen the screw until it is ready to come out and then ease it away from the assembly, (**above**).

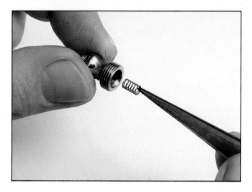

If the spring remains behind and will not shake out, it may be stuck to the inside of the air valve body by a deposit of paint. Hold the end of the spring with tweezers and then ease it to and fro until you can work it out of its housing (**left**).

The air valve pin may also just shake out, but if it sticks, use tweezers to pull it out (**right**). If your model of airbrush does not have a washer that fits around the air valve pin, use tweezers to remove the washer from the top of the air valve housing.

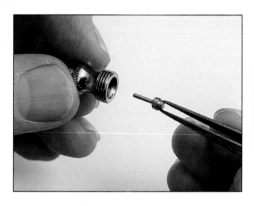

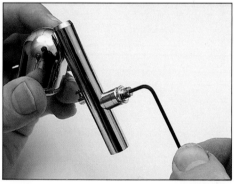

If your airbrush comes with a hexagonal screw to lock the air valve, loosen the valve with the hexagonal key that is supplied in the tool kit (**left**).

The air valve pin will probably fall out when you turn the air valve upside down, but if it sticks it can be dislodged by pushing it with the blunt end of an airbrush needle (**right**).

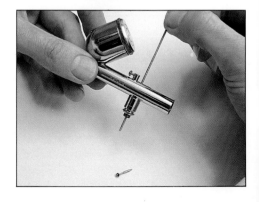

Return spring maintenance

If the needle return spring is malfunctioning you will probably be able to feel that the operation of the trigger is not as smooth as it should be when you pull the needle back. This may be because of corrosion or paint that is stopping the spring from expanding correctly, or else the spring may have become too weak to do its job.

To get at the spring, unscrew the airbrush handle. Then take off the needle chuck and slide out the needle. Now unfasten the spring box and pull out the square piece, or needle guide tube. Sometimes the needle return spring will come away with the square piece but it may stay behind, lodged in the aluminum body. If the spring does not come free, try to catch hold of the end of it with tweezers and twist it gently to see whether it is going to come loose without requiring a lot of force.

If the spring is reluctant to come free, drop the assembly into a jar of meths or brake fluid to loosen accumulation. Then pull out the spring, wash it and the body thoroughly in water and leave them to dry. If the spring has a corroded surface or if it has lost its tension, fit a new one. Polish the inside of the aluminum body with metal polish to remove any rough spots that might stop the spring from moving freely.

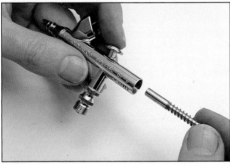

When you have removed the spring box, the spring and the needle chuck can be taken off (**left**). Check whether the spring has become corroded or contaminated by paint. If the needle has not been returning as smartly as it should when you release the trigger, the spring may have lost some of its tension.

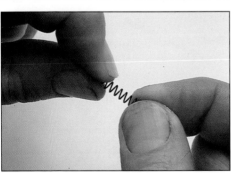

A spring that has weakened can be revitalized to some extent by pulling out the ends of the spring until it has regained its former length (**left**). If the spring has completely lost its tension, you will need to replace it with a new one.

Needle packing gaskets

The needle packing gaskets, fitted inside the body of the airbrush, allow the needle to move smoothly forward and backward, but prevent paint from being forced back into the airbrush body. If the gaskets are wrongly adjusted, or if they are worn out, the action of the needle may become faulty and paint can get into parts of the airbrush where it should not.

Follow the step-by-step strip down sequence for your airbrush until you have access to the needle packing washer. You will be able to see the screwhead of the gasket inside the airbrush body. Locate the slot by feel with your screwdriver and undo the gasket. Then, either

shake out the gasket or fish it out of the hole with tweezers. There are two small needle packing washers located behind the gasket — you will have to dig out these washers with a screwdriver. Scrape away any remaining fragments of washer until you can feel that the screwdriver is making metal to metal contact. Blow out any shreds of washer that are left behind.

There is a very easy way of fitting the new needle packing washers in exactly the right place. Take the airbrush needle and slide two new needle packing washers over the pointed end. Then slip the needle packing gasket over the blunt end of the needle and slide it along to meet the washers. Now insert the point of the needle carefully into the airbrush and push the needle as far as you can with your finger. Place a screwdriver on the blunt end of the needle and use it to push the needle through. You will be able to feel when the screwdriver comes up against the needle packing gasket. Put the screwdriver in·the slot and tighten up the gasket.

Push the needle back into the airbrush and check the tightness of the needle packing gasket by holding the airbrush up by the point of the needle. When the gasket is tightened correctly the airbrush will slide slowly down the needle under its own weight.

The other design of needle bearing does not have a screw to hold it in place but is pushed to fit in its housing. This type of needle bearing just needs to be pushed out. Choose a metal rod that is a little thicker than the airbrush needle, such as a drill bit, and slide it into the airbrush body from the rear until it meets the needle bearing. Apply steady pressure to dislodge the needle bearing. If the bearing is a tight fit you may need to protect the point of the drill with a piece of scrap wood and tap it with a hammer.

When you fit the new needle bearing, hold it with a pair of fine tweezers and slide it into a hole from the front of the body. Use the same rod or drill bit to push the new needle bearing home fully with gentle but firm pressure.

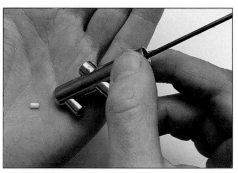

Some types of needle bearing are not held in place by threaded gaskets, but fit tightly into the airbrush body. If this is the case with your airbrush, push the bearing out with a thin metal rod that will slide through the body but that has a larger diameter than the hole through the bearing (**left**).

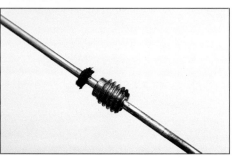

When you are refitting the new washers and the needle packing gasket, slide the washers and the gasket carefully over the point of an airbrush needle (**left**).

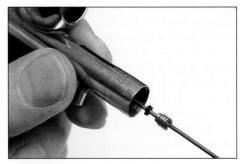

After you have slid the washers and gasket onto the needle, slide the needle into the body of the airbrush and feed it through all the way so that when you pull out the needle the washers and gasket stay behind (**left**).

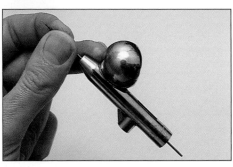

Tighten the gasket with a screwdriver to lock the washers in place (**left**). The tightness of the needle packing gasket is correct when the airbrush will just slide down the needle under its own weight.

Trigger pin adjustment

This section refers to DeVilbiss models only because no other models have a trigger pin. After the airbrush has been in use for a long period, the action of the trigger may become less positive, giving the artist less control over the airbrush. Often the reason for this is that the trigger pin has been gradually bent out of shape.

Straightening the trigger assembly needs care because the very thin metal used in the trigger and the trigger pin means that it is all too easy to make things worse by breaking the trigger. The trigger pin itself is usually chromed after it has been fitted into place, so you cannot pull it out to fit a new one.

With care, you can straighten the trigger pin assembly with a pair of pliers. If the sides of the trigger have bowed outward, squeeze them together gently with pliers until they are parallel once again. If the trigger sides have started to curve inward, try to move them apart by sliding the point of the pliers between them to force them apart again. Take care during this operation, because you can easily go too far and bend the trigger outward. Bear in mind that every time you bend the trigger it will become slightly weaker. Please note that this operation is very delicate and difficult to carry out without crushing the trigger pin.

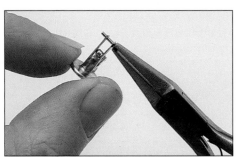

If the trigger pin has become distorted, you can straighten it by bending the sides of the trigger with a pair of pliers (**left**). Use as little force as possible when doing this job, because the trigger is made of thin metal and can easily be damaged beyond repair.

FAULT-FINDING CHART

If your airbrush does develop a fault, the root cause might lie in the airbrush itself, or with the compressor or regulator. Often, a thorough clean of the airbrush will restore peak performance but sometimes more major work will be necessary. Find the fault in the chart and then pinpoint the possible causes. If the airbrush needs to be dismantled to fix the fault, the step-by-step strip-down sequence will show you how to get at the parts of the airbrush that need mending.

PROBLEM	ANALYSIS
Air leaking from air hose	Worn washer in hose or connectors
	Connections not tight enough
Air leaking through control lever	Diaphragm assembly or air valve stem packing piece broken
Air leaking through nozzle when airbrush switched off	Air valve springs and valve stem wrongly tensioned
	Diaphragm assembly and air valve stem or ball maladjusted
Air not flowing	Drop in temperature causing pressure drop in canister
	Wrongly positioned or damaged nozzle washer or spray head washer
	Blocked air feed
	Damaged lever assembly
	Damaged air valve stem
	Damaged air valve seal
Air pressure too high	Compressor pressure too high
	Canister blowing out too much air
Blobs at either end	Hand still at start and end of stroke
	Lever not eased at start and end
	Paint released without enough air flow

MODEL	REMEDY
All types	Replace
All types	Tighten
All types except single-action spray gun	Replace. Needs professional repair
All types	Adjust, or replace
All types except single-action spray gun	Needs professional repair
All types	Put canister in cold water or replace
All internal atomization models	Refit or put in a new one
All types	Take off nozzle and spray air through airbrush. Check air valve diaphragm assembly
All double-action and independent double-action internal atomization models	Replace. Needs professional repair
All types	Replace. Needs professional repair
All internal atomization models	Replace
All types	Reduce pressure
All types	Blow off air until pressure is as required
All types	Move hand before and after operating
All types except Paasche Turbo	Practise easing lever
Double-action internal atomization models	Adjust lever action

Fault-finding chart
Continued

PROBLEM	ANALYSIS
Bumpy spray pattern	Fluctuating air supply due to no reservoir for compressor
	Nozzle dirty
	Nozzle or nozzle cap maladjusted
	Nozzle washer worn
Diffused fine line	Needle tip bent or damaged
	Dust and paint clot at nozzle tip
Dirty paint color	Paint container, paint feed, nozzle or nozzle cap dirty
Lever not returning after being pressed down	Air valve spring has lost tension
	Air valve stem sticking
Lever not returning after being pulled back, or it flops	Needle spring stuck or has lost tension
	Lever assembly broken
Needle not returning after being pulled back	Loose needle-locking nut
	Needle packing gasket squeezing needle
	Needle will not move through packing gland
Paint flooding	Paint too thin
	Needle set too far back
	Paint feed pipe or nozzle set too high
Paint leaking from nozzle	Insufficient air supply
	Loose nozzle cap

MODEL	REMEDY
All types	Add moisture trap to air supply system
All types except Paasche Turbo	Clean
All internal atomization models	Remove and adjust
All internal atomization models	Replace
All internal atomization models and Paasche Turbo	Straighten the needle
All internal atomization models and Paasche Turbo	Clean
All types	Clean
All types	Stretch spring or tighten air valve spring retainer. If necessary replace
All types except Paasche Turbo	Strip and clean, or get professional advice
Double-action and independent double-action internal atomization models	Stretch spring; clean off old grease and lubricate
Double-action and independent double-action internal atomization models	Replace. Needs professional repair
Double-action and independent double-action internal atomization models	Tighten nut
Double-action and independent double-action internal atomization models	Loosen needle packing gasket screw; clean off accumulated paint from needle packing gasket, and lubricate
Double-action and independent double-action internal atomization models	Loosen packing gasket screw and clean
All models except Paasche Turbo	Mix again
Single-action internal atomization models	Adjust needle and check lever action
Single-action spray gun and single-action external atomization models	Reset
All internal atomization models	Increase air or reduce paint supply
All internal atomization models	Tighten

Fault-finding chart
Continued

PROBLEM	ANALYSIS
Paint leaking from reservoir	Paint coming out of its container when airbrush held at an angle
	Washers and joints wrongly positioned or too loose
Paint not spraying	Nozzle not close enough to air supply
	Paint too thick or not well blended
	Feed tube not covered
	Paint flow blocked
	Dried paint on nozzle
	Needle stuck in nozzle
	Pigment settled in paint
	Needle-locking nut attaching control lever to needle loose
	Damaged lever assembly
Paint not spraying bubbles in reservoir; paint spattering	Loose nozzle cap
	Nozzle badly seated
	Nozzle washer or spray head assembly missing or damaged
	Badly fitting nozzle and nozzle cap
	Damaged or split nozzle
Spattering at an angle	Bent needle or split nozzle
Spattering at start	Lever is being released too quickly after each stroke, causing build-up of paint
	Needle is damaged
	Accumulation of paint in nozzle cap

MODEL	REMEDY
All types except single-action spray gun	Hold airbrush level
All internal atomization models	Check and adjust
Single-action spray gun and single-action external atomization models	Reset nozzle
All types	Empty paint container and remix paint
All types except Paasche Turbo	Put in more paint
All types except Paasche Turbo	Clean
All types except Paasche Turbo	Take off nozzle and needle and clean; tighten nut attaching control level to needle
All internal atomization models	Adjust. Check needle-locking nut
All types except Paasche Turbo	Add diluent. Agitate the needle or paint cup
All internal atomization models	Tighten
All double-action models	Needs professional repair
All internal atomization models	Tighten
All internal atomization models	Take off and adjust
All internal atomization models	Replace. Needs professional repair
All internal atomization models	Replace
All types except single-action spray gun and Paasche Turbo	Replace
All internal atomization models and Paasche Turbo	Replace
Double-action and independent double-action internal atomization models	Release lever more gently
Double-action and independent double-action internal atomization models	Replace
All internal atomization models	Insure that needle is secure. Clean with a brush and thinners

Fault-finding chart
Continued

PROBLEM	ANALYSIS
Spattering at start	Impurities in nozzle
	Excess moisture or dirt in air valve
Spattering at end	Dirt or excess moisture in air valve
	Needle or nozzle are damaged or dirty
Spattering or spitting	Not enough air pressure relative to air supply
	Impurities in nozzle or nozzle cap
	Accumulation of paint in nozzle cap
	Paint is too thick, or badly mixed
	Worn or cracked nozzle
	Ill-matched nozzle and needle
	Impurities or excess moisture in air supply
	Air valve clogged with paint
	Paint has seeped into body opening, causing diaphragm assembly to break
Tendril effect	Airbrush too close to painting surface
	Too much paint released
	Paint being released before air
Uneven strokes	Airbrush being worked at wrist, not from whole arm
	Impurities in nozzle

MODEL	REMEDY
All types	Take off and clean
All types	Remove nozzle and blast air through. Check the filter at the source of air supply
All types	Remove nozzle and blast air through. Check filter at source of air supply
All internal atomization models	Replace or clean
All types	Adjust air pressure
All types	Remove and clean
All internal atomization models	Clean with brush and thinners. Make sure needle is secure
All types	Empty and clean. Mix fresh paint well
Single-action external and internal atomization and double-action internal atomization models	Replace
All internal atomization models	Replace one or the other
All types	Take off nozzle and blast air through. Check filter at source of air supply
All internal atomization models	Replace worn air valve washer (which is letting paint through). Diaphragm assembly needs professional repair
All internal atomization models and Paasche Turbo	Professional repair
All single-action models	Move away or adjust nozzle and needle setting
Independent double-action models and Paasche Turbo	Reset control lever to correct paint:air ratio
Double-action internal atomization models	Adjust lever action
All types	Work from whole arm
All types except Paasche Turbo	Clean

4
STRIP-DOWN AND REASSEMBLY

Badger 100 LG/Badger 200 EX/Badger 400 Touch-up gun/Conopois/DeVilbiss Super 63E/DeVilbiss Aerograph Sprite/ DeVilbiss MP Spray Gun/Olympos SP-B/Paasche AB Turbo/Paasche VLS/ Paasche AEC Air eraser/Paasche H3/ Thayer and Chandler Model C

Airbrushes consist of a lot of parts, but dismantling them is not as complicated as it may seem and there is very little risk of damaging anything as long as you take reasonable care. In the step-by-step strip-down sequences, we have shown all the important stages of the dismantling procedure. Usually, reassembling the airbrush is just a reversal of the dismantling process, but there are occasional differences and these have been highlighted in the photographic sequences.

Badger 100 LG

Pages 44-49

Badger 200

Pages 50-53

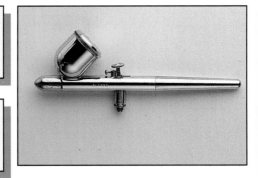

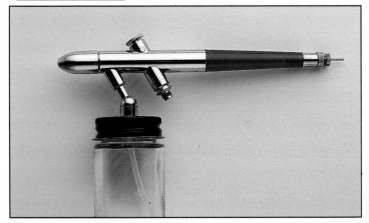

Badger 400 Touch-up Gun

Pages 54-59

Conopois

Pages 60-61

Conopois airbrushes take color cups of different sizes. The model (*left*) has a larger cup than that shown on pages 60-61.

De Vilbiss Super 63

Pages 62-71

De Vilbiss Sprite

Pages 72-73

**De Vilbiss
MP Spray Gun**

Pages 74-79

Olympos SP-B

Pages 80-83

Paasche Turbo

Pages 84-87

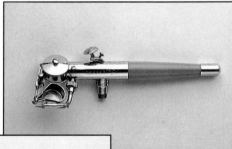

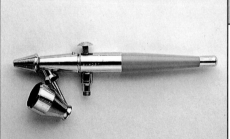

Paasche VLS

Pages 88-91

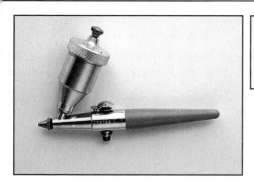

**Paasche
Air Eraser**

Pages 92-95

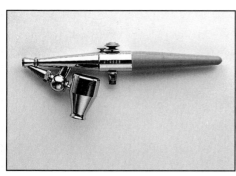

Paasche H3

Pages 96-99

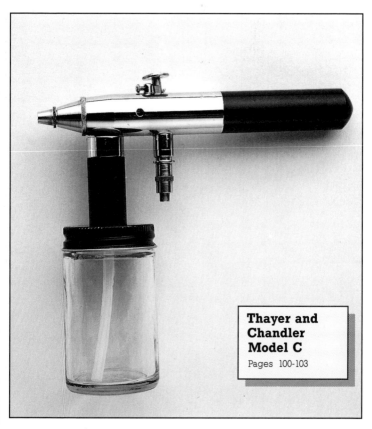

**Thayer and
Chandler
Model C**

Pages 100-103

Badger 100LG

This airbrush is the latest model to be produced by Badger. It is a double-action design and is notable for its large gravity-fed reservoir. The instructions that follow also apply to Badger models GXF; 100 XF, IL, HD; and 150 XF, IL, HD.

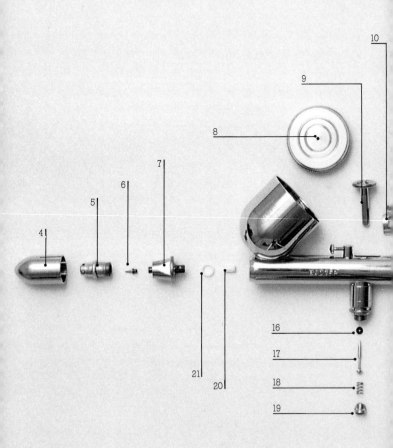

Strip-down

Unscrew the handle of the airbrush and loosen the needle-retaining nut. Remove the handle.

1 Handle
2 Needle 50-0401/2
3 Body shell
4 Protective cap 50-022
5 Spray regulator
 50-0371/2
6 Tip 50-0391/2
7 Head 50-0381/2
8 Cup lid
9 Trigger 50-019
10 Back lever 50-042
11 Tube shank 50-030
12 Needle tube 50-032
13 Needle tube spring
 50-044
14 Spring screw 50-031
15 Needle chuck 50-010
16 'O' ring 50-0141
17 Plunger 50-014
18 Plunger spring 50-020
19 Valve screw 50-015
20 Teflon needle
 bearing 50-046
21 Teflon head seal
 50-055

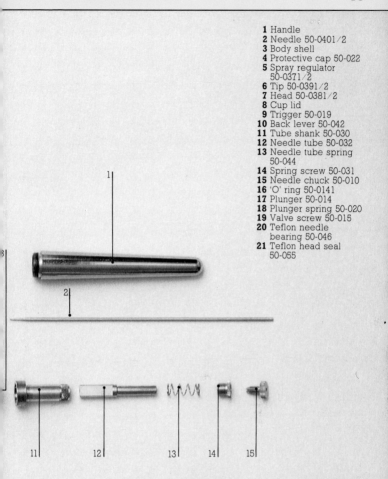

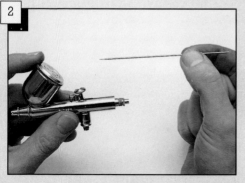

Slide the needle
carefully out of the
body, making sure that
you do not bend the
tapered point.

Unscrew the knurled end of the needle guide assembly and slide it out.

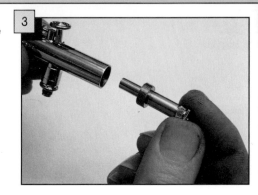

The needle guide assembly consists of four small components.

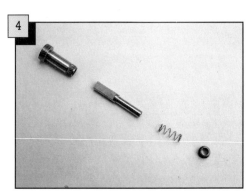

Remove the trigger and the back lever. These parts should fall out when you turn the airbrush upside down.

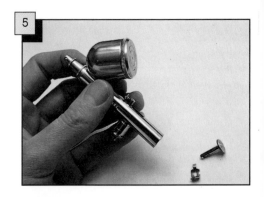

Remove the head using the wrench that is supplied with the airbrush. The Teflon head seal should come off with the head — if it does not, pry it out of the body.

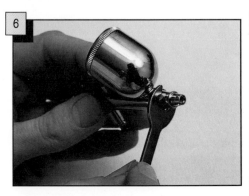

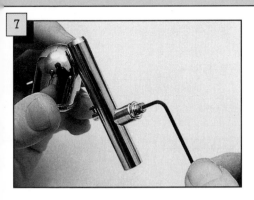

7 Undo the air valve spring retainer using a hexagonal key to fit into the hexagonal hole.

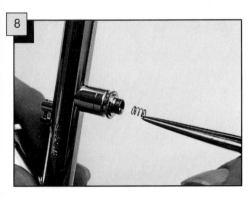

8 Take out the air valve spring using fine-pointed tweezers to draw it out.

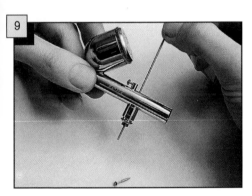

9 Remove the air valve pin. If it does not fall out, push it through from above with the blunt end of a needle.

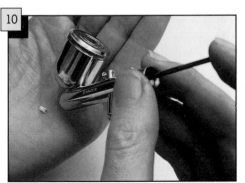

10 Choose a thin rod or a drill bit that will fit inside the airbrush body and push out the needle bearing. It may be necessary to tap the rod gently with a hammer to shift the bearing.

If the tip needs to be renewed, perhaps because it is damaged, use flat-nosed pliers to loosen it. Push and turn the pliers at the same time so that they do not slide down the tip.

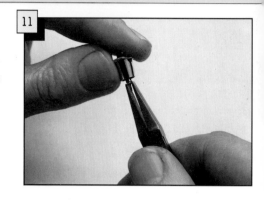

Reassembly

Refit the needle bearing. Hold the bearing with pliers and slide it into the hole. Because the bearing is a parallel tube, there is no wrong way around.

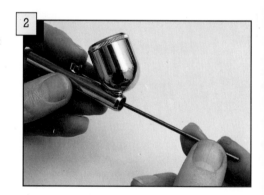

Seat the bearing. Make sure that the bearing is fully home by pushing it firmly into the hole with a rod.

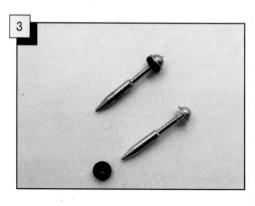

Renew the O-ring. The O-ring on the air valve stem can be rolled off the pointed end of the air valve stem. Some solvents attack the O-ring and cause it to swell.

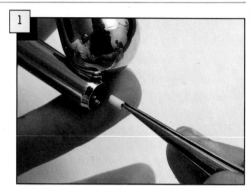

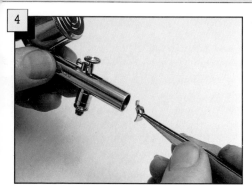

Refit the back lever. This fits just behind the trigger. Hold it with tweezers and thread it into the body, sitting the tag at the top of the back lever against the trigger.

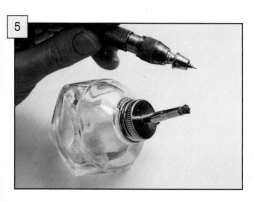

To fit a new tip, screw the tip into the head until there is just 1mm of thread showing. Then heat the tip over a spirit burner.

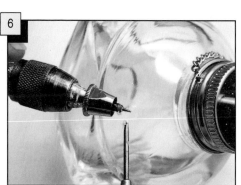

Heat a screwdriver and scrape some wax onto the screwdriver tip. Spread the molten wax on the exposed thread, then run the tip quickly in the flame to make the wax run.

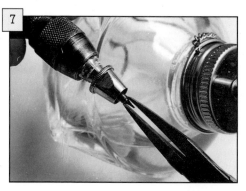

Warm the pliers and then tighten up the tip fully.

Badger 200

This airbrush is a single-action model, suitable for a wide variety of uses including modelmaking and car customizing. It is a well-engineered airbrush and falls into the medium price range.

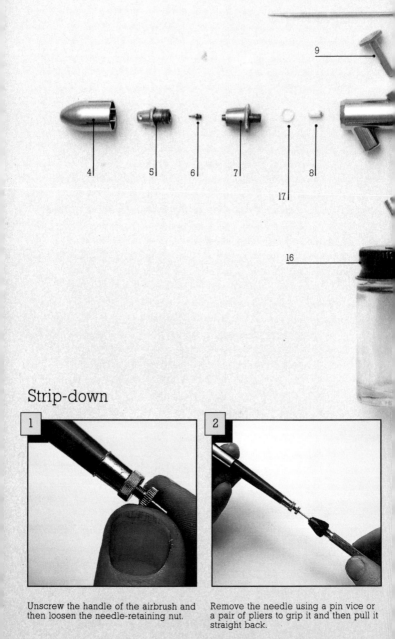

Strip-down

Unscrew the handle of the airbrush and then loosen the needle-retaining nut.

Remove the needle using a pin vice or a pair of pliers to grip it and then pull it straight back.

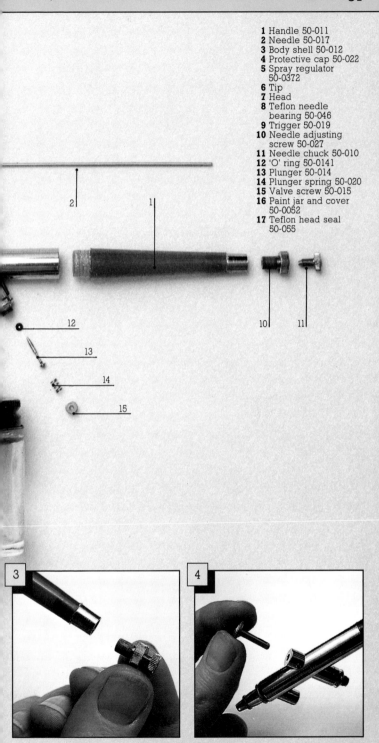

1 Handle 50-011
2 Needle 50-017
3 Body shell 50-012
4 Protective cap 50-022
5 Spray regulator 50-0372
6 Tip
7 Head
8 Teflon needle bearing 50-046
9 Trigger 50-019
10 Needle adjusting screw 50-027
11 Needle chuck 50-010
12 'O' ring 50-0141
13 Plunger 50-014
14 Plunger spring 50-020
15 Valve screw 50-015
16 Paint jar and cover 50-0052
17 Teflon head seal 50-055

3

Unscrew the needle-retaining collet. Grip the knurled edge with pliers if the collet is stiff.

4

Lift out the trigger. The trigger will lift out easily when you pull it upward.

Unscrew the head. The wrench that comes with the airbrush fits the flats on the head.

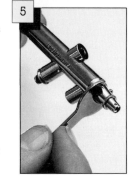

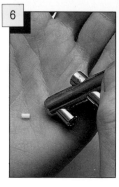

Push out the needle packing gasket. Use a metal rod or an old twist drill to push out the packing gasket.

Refit the packing gasket. Start off by using tweezers to position the gasket, then push it home firmly with a rod.

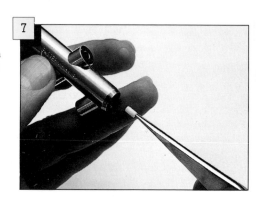

Push the needle packing gasket with the rod until you can feel that it has reached the end of its housing.

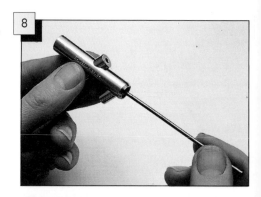

Remove the air valve spring retainer.

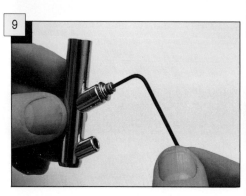

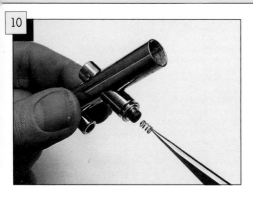

Remove the air valve spring. It will usually come out easily with the use of tweezers.

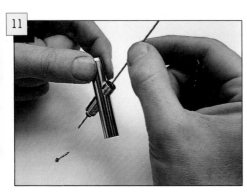

Push out the air valve pin using the blunt end of a needle to push the air valve pin through.

Reassembly

When reassembling the airbrush, screw the handle home first then screw the large nut of the needle-adjusting collet home fully against the tail of the body.

Screw in the small nut of the collet, then push the needle home, turning it as it goes in.

When the point of the needle is visible in the tip, turn the smaller collet nut toward the larger one until it is tight.

Badger 400 Touch-up Gun

The Badger 400 is similar in principle to an industrial spray gun but is constructed on a smaller scale. It is a popular choice for car customizers.

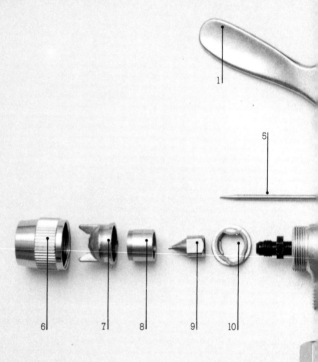

Strip-down

To remove the color cup, press the locking lever with your thumb and the color cup will be free to come away.

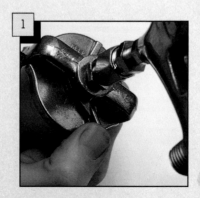

1

1 Trigger 40-005
2 Trigger cam 40-004
3 Air valve plunger 40-014
4 Trigger pin 40-043
5 Needle 40-023/4/5
6 Air nozzle nut 40-022
7 Air nozzle 40-030/1/2
8 Paint tip sleeve 40-049
9 Paint tip 40-027/8/9
10 Air deflector 40-002
11 Body 40-001
12 Fan control spring 40-034
13 Fan control needle 40-033
14 Needle spring 40-037
15 Needle adjusting screw 40-038
16 Fluid needle packing 40-012
17 Packing nut 40-013
18 Valve pin 40-017
19 Valve ball 40-018
20 Valve spring 40-019
21 Valve screw 40-020
22 Paint cup 40-050

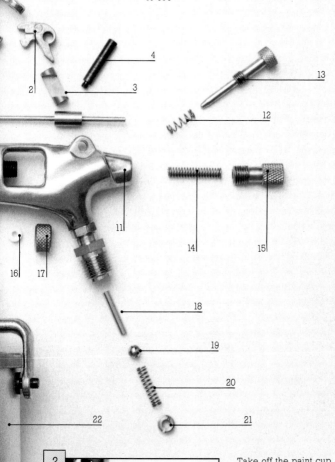

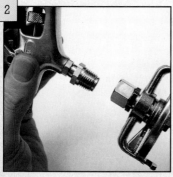

Take off the paint cup assembly by loosening the nut farthest from the airbrush body to separate the assembly from the body.

Loosen the needle adjusting screw. The spring may come off with the screw or may remain in place on the needle.

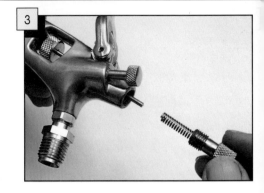

Pull the needle through the body of the gun and out, taking care not to catch its pointed end.

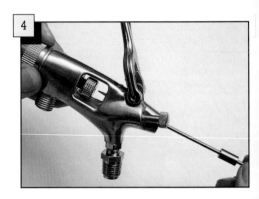

Take off the air nozzle nut. If necessary, grip the nut with pliers to break the seal, then use your fingers.

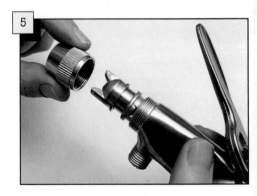

Remove the air nozzle easing it away from the body of the gun.

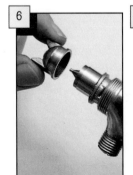

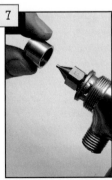

Remove the paint tip sleeve – this will slide off with finger pressure.

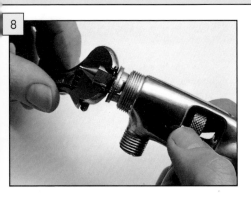

To remove the paint tip, grip the flats of the hexagon with a wrench and then unscrew the tip with your fingers.

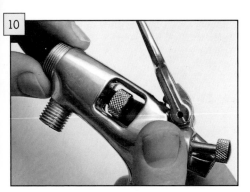

Take off the air deflector. This component can be fiddly to remove, so just turn it gently with your fingers until it comes free.

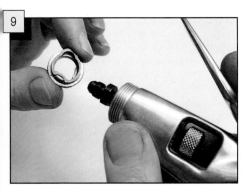

Undo the packing nut with finger pressure and then it will come out of the body.

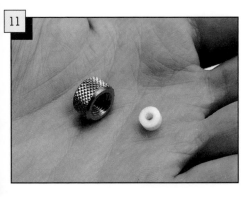

Remove the fluid needle packing. This part sits inside the fluid needle packing nut and should shake out when the nut is turned upside down.

Undo the fan control
needle. The spring that
surrounds the fan
control needle comes off
at the same time.

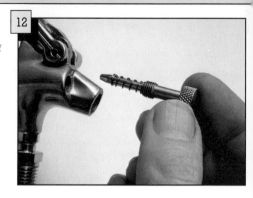

Take out the fan control
washer. This sits in the
fan control recess and
can be pulled out with
tweezers.

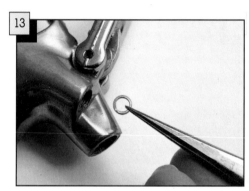

Remove the fan control
packing by prying it
from the fan control
recess with pliers.

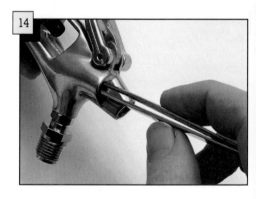

Undo the screw that
passes through the
trigger hinge and
remove the trigger.

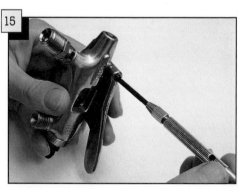

When you have withdrawn the trigger hinge screw, the trigger will lift away.

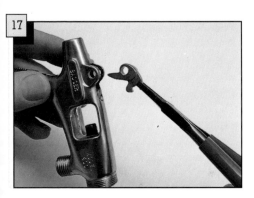

Remove the trigger cam. Fine-pointed pliers are ideal for holding the cam and pulling it out.

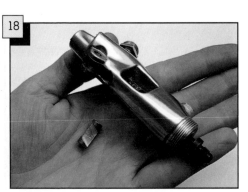

Take out the air valve plunger. The plunger should just shake out of the body of the gun.

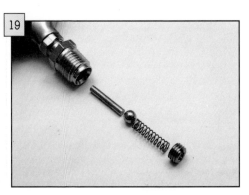

Remove air valve retaining screw. Note that there is a spring in this assembly that may shoot out if you are not careful.

Conopois

Many features of the design of the Conopois make it unusual among airbrushes, such as the needle travel limiting screw on the trigger. It is a single-action model that is made in Britain.

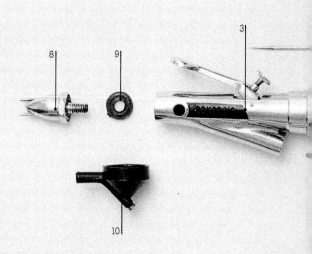

Strip-down

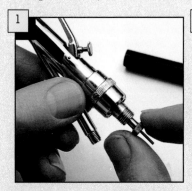

To remove the handle unscrew it and then loosen the needle-locking nut.

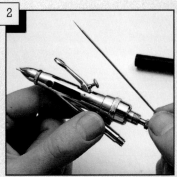

Slide the needle back until it is free, taking care not to damage its fine point, and take it out.

1 Handle
2 Needle
3 Body
4 Needle locking screw
5 Air valve pin
6 'O' Ring
7 Air valve
8 Head
9 Seal
10 Color cup

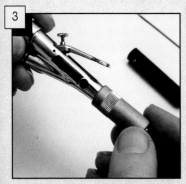

Loosen the head. A box wrench, supplied with the airbrush, fits over the head to unfasten it. Once the head is loose, you can unscrew it with your fingers.

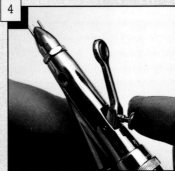

Adjust the trigger travel screw. This device controls the degree to which the needle is retracted when you press down the trigger.

De Vilbiss Super 63

The DeVilbiss Super 63 has been one of the most popular indepen-
dent double-action airbrushes for many years. Some parts of the basic
design have been developed further but there are components that
could be taken from a forty year old Super 63 and fitted straight to a
brand new model.

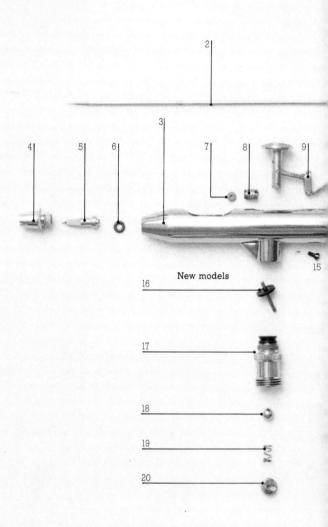

New models

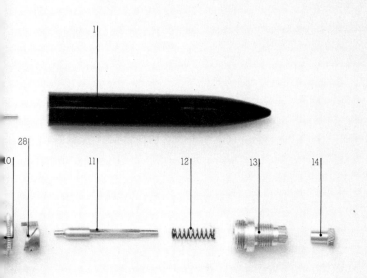

Pre-1980 models

21
22
23
24
25
26
27

1 Handle A423
2 Needle A22
3 Body A417/8
4 Aircap
5 Nozzle
6 Nozzle washer
7 Needle gasket washer A105
8 Needle packing gasket NSA24
9 Lever and linkage A452
10 Cam ring A8
11 Square piece NSA28
12 Needle spring A27
13 Spring box A50
14 Needle locking nut NSA29
15 Screw A32
16 Valve stem and seal ABA-405
17 Air valve
18 Steel ball SPS1741
19 Air valve spring ABA-55
20 Air valve spring retainer NSA13
21 Diaphragm A20
22 Diaphragm nut A21
23 Air valve box A102
24 Air valve washer A18
25 Air valve stem A103
26 Air valve spring ABA-55
27 Air valve spring retainer NSA13
28 Cam A9

Strip-down

Remove the handle. This should unscrew easily, with only a little force being needed to start the handle turning.

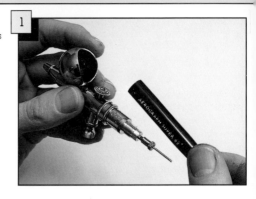

Remove the needle chuck. You may need pliers initially if the chuck has been corroded.

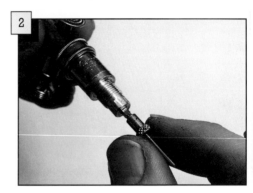

To withdraw the needle, rest your finger against the needle as it slides out of the airbrush — this will minimize the risk of damaging the delicate point of the needle as it comes out.

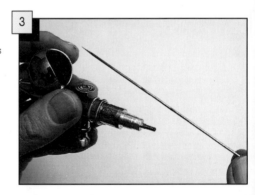

Undo the air cap using pliers if your fingers will not grip the air cap tightly enough. The nozzle may come away with the air cap.

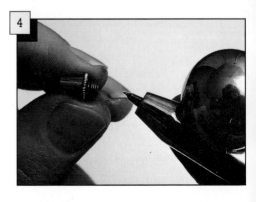

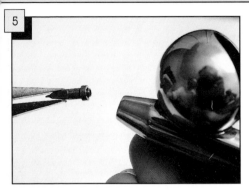

5

If the nozzle does not come out with the air cap, use tweezers to pull it out.

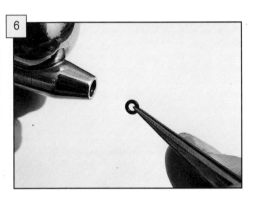

6

Remove the nozzle washer. If the washer does not come out of the airbrush together with the nozzle, use tweezers to pull it out of its housing.

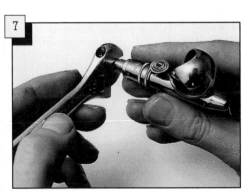

7

Undo the aluminum body. There is a hexagon on the aluminum body but the flats often become rounded — use parallel-action pliers or an adjustable wrench to grip the body.

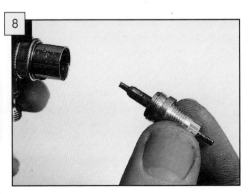

8

Remove the aluminum body. When it comes off, the brass square piece may come out of the airbrush body at the same time.

Pull out the square piece. When the square piece comes out, the needle return spring may come away, too, or may remain inside the aluminum body.

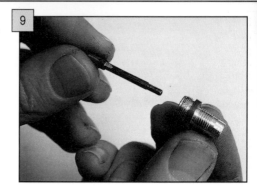

Pull out the spring. Tweak the spring out with tweezers, turning it to and fro to loosen it, if necessary. A jammed spring may need to be soaked in meths or brake fluid before it will come out of the body.

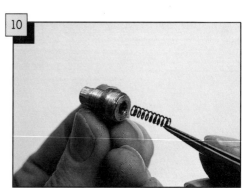

Undo the screw in the body, using a small screwdriver to loosen the screw first. Then shake it out into a suitable container.

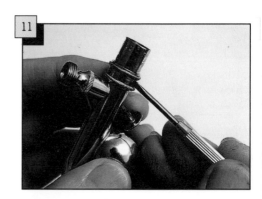

Undo the screw in the cam control ring. If you have trouble turning any small screws in airbrushes, loosen them with aerosol lubricant or releasing agent. Remove the cam control ring. It may slide off with finger pressure, but if not, rock it to and fro until it comes free, then slide it off.

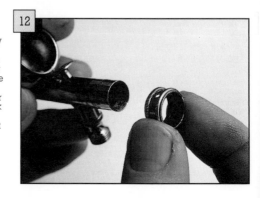

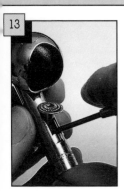

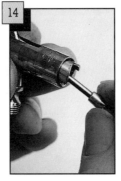

Start the cam moving by levering it gently with a screwdriver until you can grip it.

Remove the cam from inside the body.

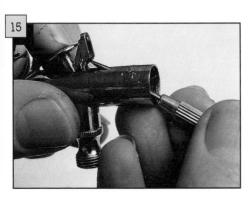

Lift up the stirrup with the end of a screwdriver until you can get hold of it to pull it out.

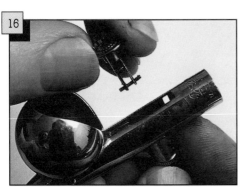

Give the assembly a half turn so that there is clearance for the trigger pin and then lift out the trigger.

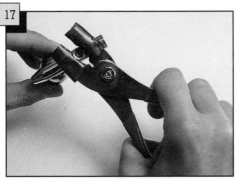

Using pliers covered with a soft material such as copper, loosen the air valve, and then unscrew it with your fingers.

Remove the air valve. It should unscrew easily once the pliers have loosened it.

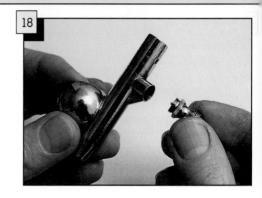

Loosen the diaphragm nut with the special tool supplied, which has three prongs to engage with the three holes in the nut.

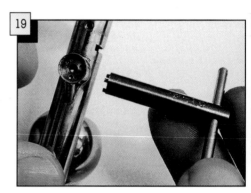

If you do not have the special tool, use fine-pointed pliers to turn the diaphragm nut.

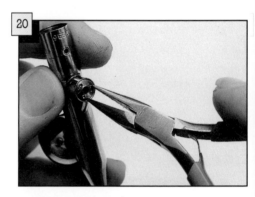

Grip the end of the diaphragm with flat-nosed pliers and pull it out.

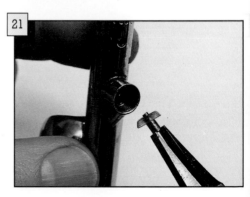

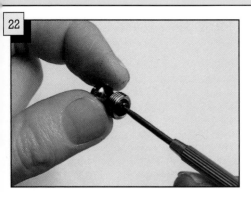

22 Unscrew the air valve spring retainer in the end of the air valve.

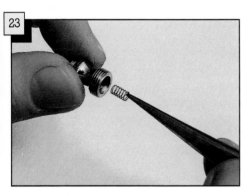

23 Remove the air valve spring using tweezers to catch hold of the end of the spring.

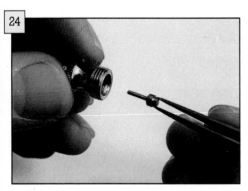

24 Take out the air valve pin. The pin will either fall out or may need to be eased out with tweezers.

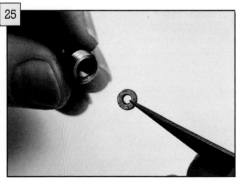

25 Remove the air valve washer. This washer is located at the bottom of the hole and you will have to dig it out with tweezers.

Engage the tip of a screwdriver with the needle packing gasket by feel, and then unscrew the gasket.

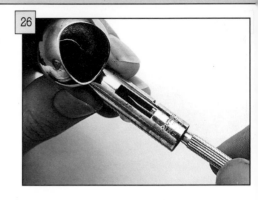

When you have unscrewed the needle packing gasket, hold it with tweezers and pull it out of the body.

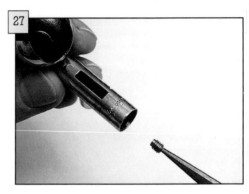

Now dig out the needle packing washers with a screwdriver. Make sure you have got both of the washers out and that no bits of them are left behind.

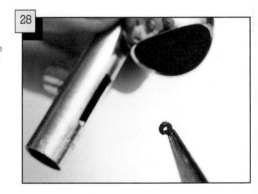

Reassembly

When refitting the new washers and the needle packing gasket, slide both washers and the gasket onto an old, straight needle.

Then slide the complete assembly into the body as far as you can push it with your fingers.

Follow the needle with a screwdriver until the needle is pushed as far as it will go. Then engage the screwdriver in the slot of the gasket and tighten it up. The gasket is correctly tightened when the airbrush body will just slide down the needle under its own weight.

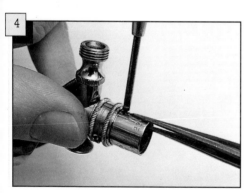

Put the trigger back in place, then tighten the lower screw. Hold the heel of the trigger and position the hole in the heel over the screw. Hold the heel to the body with tweezers, turn the assembly over and tighten the screw.

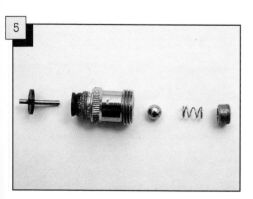

Some Super 63s have the type of air valve assembly shown here. The valve stem and the seal are fragile components which must be renewed if they are faulty.

DeVilbiss Sprite

The Sprite comes lower down the DeVilbiss range than the Super 63. It is a gravity-fed double-action airbrush and is suitable for students and hobbyists.

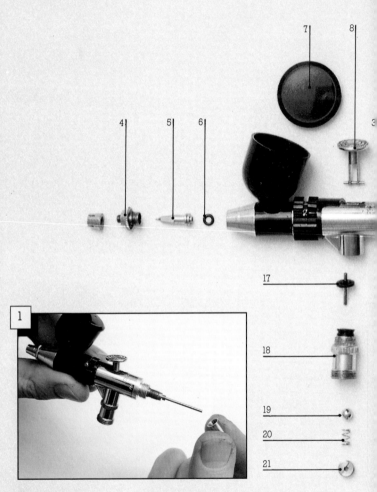

Strip-down

Remove the needle-locking nut. This should be finger tight only and so should come away easily.

Remove the clutch piece. This component is located behind the needle-locking nut and slides off the needle.

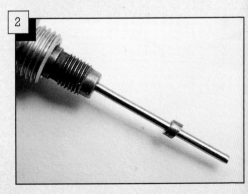

1 Handle
2 Needle
3 Body
4 Air cap
5 Nozzle
6 Nozzle washer
7 Cup lid ABA-5
8 Control lever ABA-404
9 Needle packing A105
10 Packing gasket ABA-17
11 Retaining ring
12 Needle collar ABA-14
13 Needle spring ABA-16

14 Spring box ABA-6
15 Clutch piece ABA-27
16 Needle locking nut ABA-15
17 Valve stem and seal ABA-404
18 Air valve
19 Steel ball SPS-1741
20 Air valve spring ABA-55
21 Air valve spring retainer NSA-13

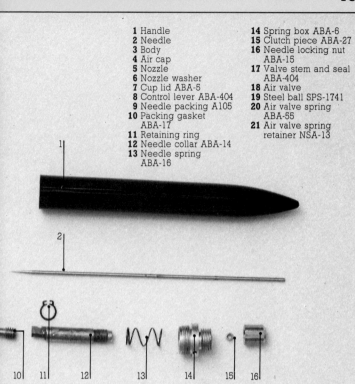

3 This exploded view shows how the trigger and spring assemblies go together.

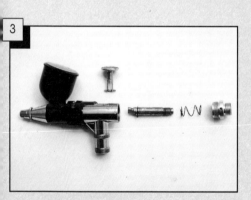

4 Remove the spring box. You may need the extra force of parallel-sided pliers to break the seal between the spring box and the body.

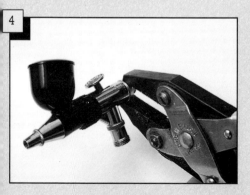

De Vilbiss MP Spray Gun

The MP is really a lightweight industrial spray gun on a small scale. It is suitable for medium detail work, large background spraying and 3D applications.

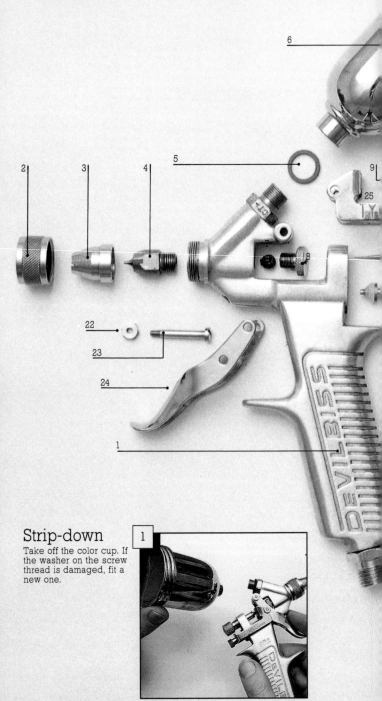

Strip-down

Take off the color cup. If the washer on the screw thread is damaged, fit a new one.

1 Handle MPS-21
2 Air cap retaining nut 2207-54
3 Air cap
4 Fluid tip
5 Washer
6 Color cup 102 & 402
7 Packing 2207-18
8 Fluid needle packing nut 2207-19
9 Nut SPS-683-P
10 Fulcrum screw 2207-9
11 Fluid needle
12 Fluid needle spring box 2207-6
13 Fluid needle spring
14 Fluid needle adjusting screw 2207-5
15 Air valve needle 2207-438
16 Air valve spring 2207-17

17 Air valve packing box 2207-12
18 Packing 2207-18
19 Air valve packing box washer 2207-13
20 Air valve screwed washer 2207-14
21 Air valve locking nut 2207-15
22 Nut SPS-683-P
23 Trigger and link screw 2207-10
24 Trigger 2207-8
25 Link 2207-11

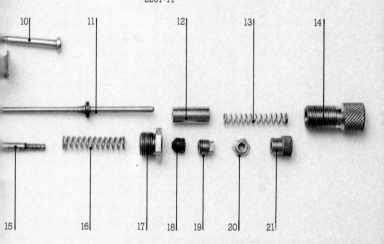

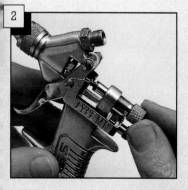

2

Remove the fluid needle adjusting screw. This screw should be finger-tight only and will come off easily.

Remove the fluid needle spring and spring box. These two components generally come off as one unit, but if the spring box stays behind it can be pulled off separately.

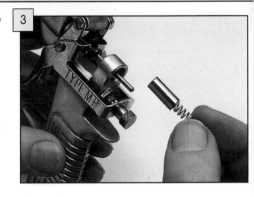

Take out the needle. The needle may slide out easily but you may need to use pliers to start it moving.

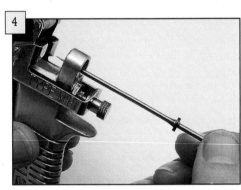

Remove the air cap retaining nut. It will probably come away from the airbrush and leave the air cap behind.

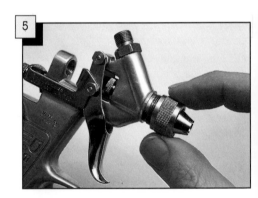

If the air cap has not come off with its retaining nut, pull it off with your fingers.

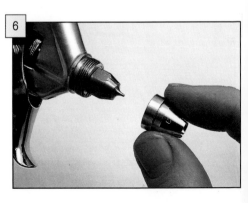

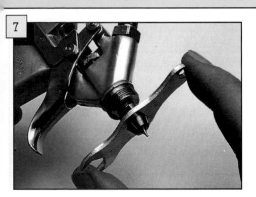

Remove the fluid tip. The wrench supplied with the Spray Gun fits over the fluid tip and unscrews it.

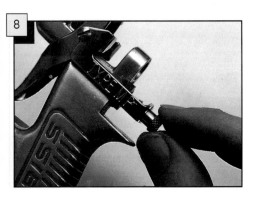

Unscrew the air valve locking nut. If the nut is tight, grip the knurled edge gently with pliers to turn it.

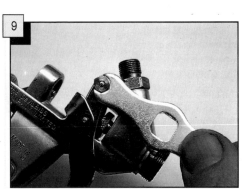

Undo the nuts on the trigger and link screw and the fulcrum screw. Use the wrench supplied for this operation.

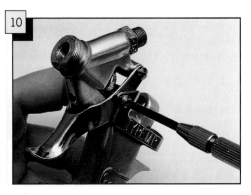

Now turn the airbrush around and take out the screws so that the link and fulcrum can be removed.

Take off the link, easing it away from the body of the Spray Gun.

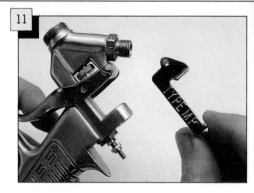

In the same way as the trigger, the fulcrum can now be eased away.

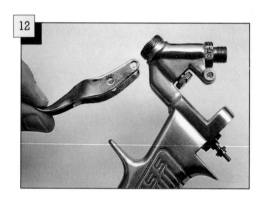

Unscrew the fluid needle packing nut. It may only need finger pressure, but there is a large slot in it for a screwdriver, if necessary.

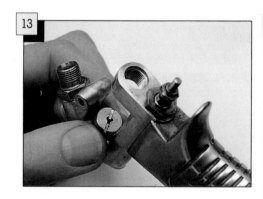

Remove the fluid needle packing gasket. This is a barrel-shaped component inside the body and will need tweezers to pull it out.

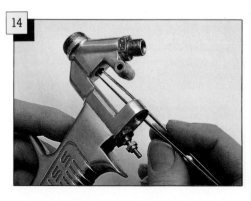

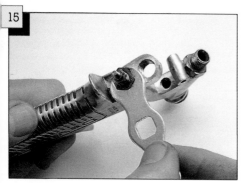

Unfasten the air valve assembly. The wrench that comes with the Spray Gun fits over the nut.

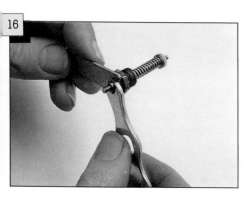

Loosen the air valve. This job requires both of the wrenches that are in the Spray Gun's tool kit.

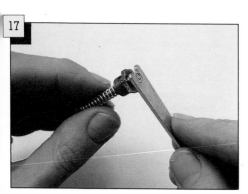

Remove the air valve packing box washer. The smaller of the two wrenches in the toolkit fits the nut.

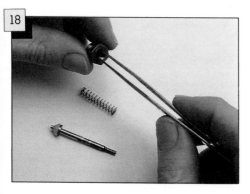

Using fine-pointed tweezers to catch hold of it, take out the air valve packing.

Olympos SP-B

This airbrush is a top-of-the-range model from Japan. It is a double-action design, having the unique feature of a line control at the tail of the airbrush. The strip-down methods for this airbrush also apply to all other models in the Olympos range, as well as those in the Iwata, Rich, and Hohmi ranges.

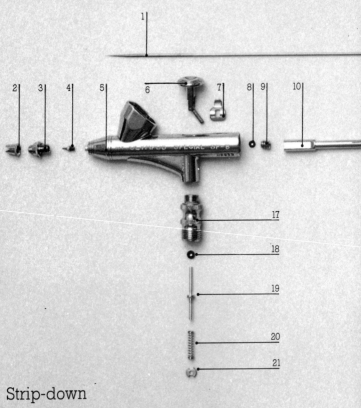

Strip-down

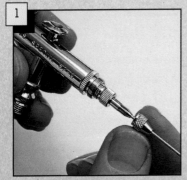

Loosen the needle-locking nut. Once you have unscrewed the handle you will find that the needle locking unit is accessible.

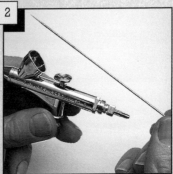

Withdraw the needle by sliding it back until it is free. Be careful not to catch its tapered point.

1 Needle
2 Needle cap
3 Nozzle cap
4 Nozzle
5 Body
6 Trigger
7 Back lever
8 Needle packing
9 Needle packing
 gasket
10 Needle tube
11 Needle spring
12 Spring tension
 adjuster
13 Spring box
14 Needle chuck
15 Handle
16 Colour flow adjuster
17 Air valve body
18 'O' ring
19 Valve pin
20 Valve spring
21 Valve spring retainer

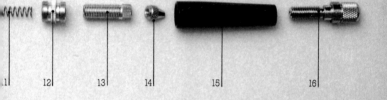

11 12 13 14 15 16

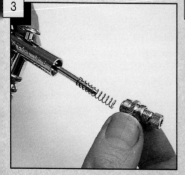

3

Undo the spring box. The spring inside the spring box may fly out so ease the spring box out slowly.

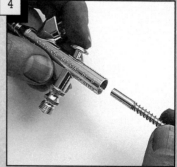

4

Pull out the spring and needle chuck. These components should come out of their housing quite easily.

Hold the back lever with tweezers and turn it through a right-angle before you try to pull it out.

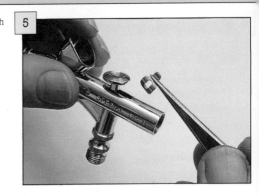

Remove the trigger. This part should come out easily with finger pressure alone.

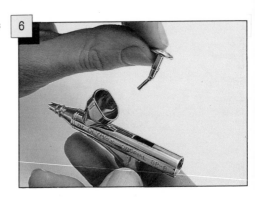

Remove the air valve using pliers to break the seal, and then unscrew the air valve with your fingers.

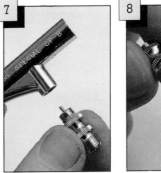

To undo the lower valve spring pin guide use fine-pointed pliers to engage the slots on each side of the retainer and then unscrew it.

These components make up the air valve. Make sure that they are all in place when you reassemble the air brush.

Take off the nozzle and needle cap. You may need to grip the knurled edge with pliers to start them moving.

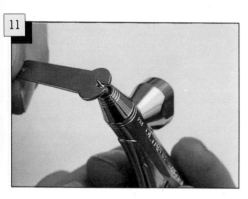

Remove the tip. The wrench that is supplied with the airbrush is designed to fit the tip.

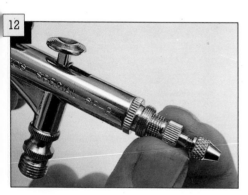

To adjust the spring tension, the spring tension adjuster can be turned to vary the resistance of the spring.

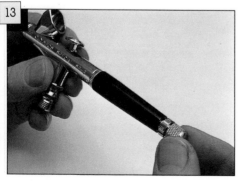

Adjust the needle travel stop. This control limits the travel of the needle and hence the amount of color that will be mixed with the air.

Paasche Turbo

The Turbo is probably the most specialized airbrush available today. Its design and appearance are unlike any other airbrush. A full strip-down of the Turbo is a job for professional airbrush mechanics but there are a lot of adjustments that amateurs can make that will keep it running well.

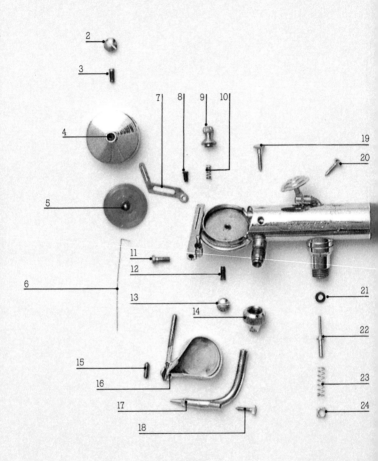

Adjustment

Adjust the needle speed. Turning this screw controls the amount of air that reaches the turbine and so controls the speed of the needle.

1 Body shell A122
2 Top grease cup A114
3 Top shaft bearing A133
4 Wheel housing A131
5 Power wheel A172
6 Needle A116
7 Walking arm A107
8 Walking arm Screw A106
9 Needle guide A142
10 Needle guide spring A143
11 Colour cup screw A160
12 Bottom shaft bearing A154
13 Bottom grease cup A114
14 Air blast tube locknut A173
15 Needle bearing A177
16 Color cup A179
17 Air tube A138
18 Stipple adjuster A146
19 Speed regulator screw A140
20 Lever adjusting screw A60
21 Valve washer A52
22 Valve plunger H21A
23 Valve spring A22
24 Air valve nut A23A
25 Spare needles A116
26 Protecting cap VL118

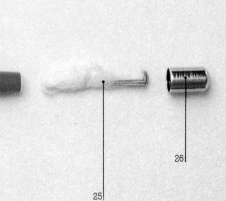

Set the stipple adjuster. This adjustment controls the speed of the air through the nozzle.

Set the finger lever adjusting screw. This control regulates the position of the walking arm.

Adjust the color cup. You can set the angle of the color cup for maximum convenience according to the angle at which you are spraying.

This is the lowest position of the color cup (the air blast tube has been moved to one side for clarity).

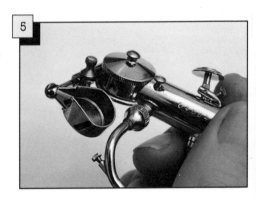

The highest position to which the color cup can be set.

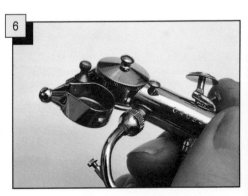

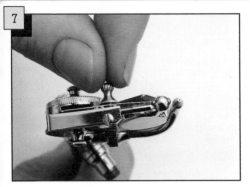

Adjust the needle guide. This part steadies the needle as it moves backward and forward.

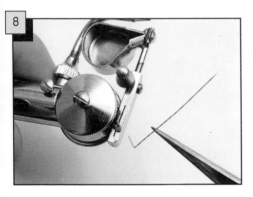

Hook the needle onto the walking arm. Try not to bend the needle as it is very delicate.

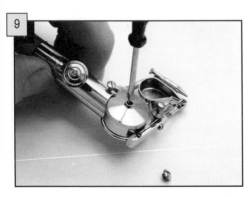

Adjust the bearing. The bearing adjuster screw lies underneath the grease cup.

Paasche VLS

The VLS is a large-scale airbrush that is often used by model makers. It is exceptionally versatile in the range of paint types that it can handle. The instructions that follow apply also to the Paasche VJR and V ranges.

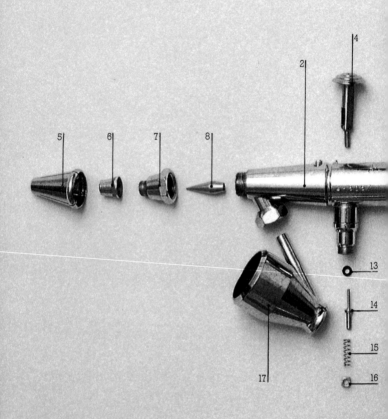

Strip-down

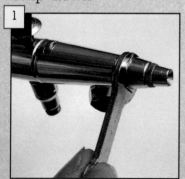

Unscrew the head using the wrench that is supplied with the airbrush for this job.

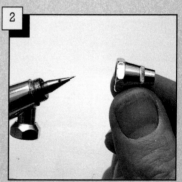

Remove the air cap. If the tip stays in the air cap, do not force it out with pliers, but heat the assembly over a spirit burner and then drop it into cold water to free the parts.

1 Handle VL-134
2 Shell VLS-163
3 Needle VLN-1.3.5
4 Finger lever VL-174
5 Head cap VL-189
6 Aircap VLA-1.3.5
7 Aircap body VLB
8 Tip VLT-1.3.5
9 Rocker assembly VL-191A
10 Spring VL-140
11 Needle adjusting sleeve VL-136A
12 Locking nut VL-141
13 Valve washer A-52
14 Valve plunger H-21A
15 Valve spring A-22
16 Air valve nut A-23A
17 Cup VL ¼oz

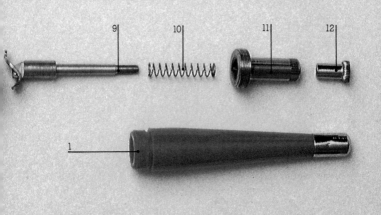

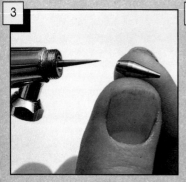

Ease the tip away from the body with your fingers.

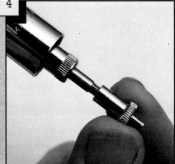

Loosen the needle-locking nut by unscrewing this component until it slides off the needle.

Withdraw the needle easing it out of the airbrush body and taking care not to damage the point.

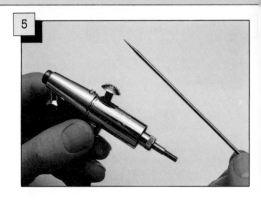

Unscrew the adjusting sleeve. Use soft-jaw pliers if necessary to start it moving.

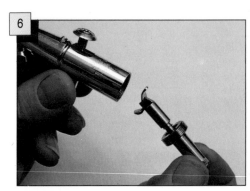

The needle adjusting sleeve, spring and needle support fit together in this sequence.

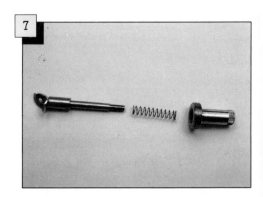

Remove the trigger. The trigger will lift easily out of the airbrush body.

Remove the air valve, using a screwdriver wide enough to fill the slot, and ease the assembly apart carefully, because the spring may fly out.

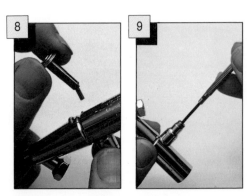

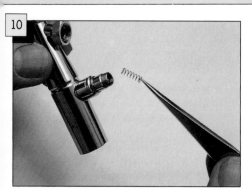

If the air valve spring stays behind when you take out the air valve, ease it out of its housing with pliers.

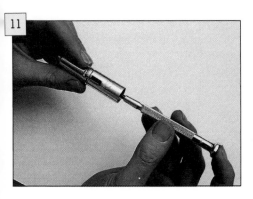

Unscrew the needle packing screw. Reach for the slot with a screwdriver and then loosen the screw.

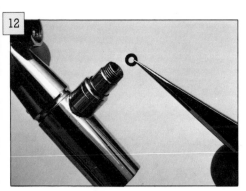

Remove the air valve washer. You may need to use a pin to dig it out of the bottom of the recess.

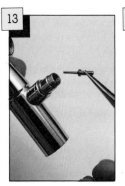
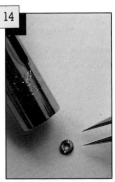

Remove the air valve pin using tweezers to pull it out. Apply solvent if the pin is stuck in place with paint.

The needle packing screw will usually shake out but you may need to help it with tweezers.

Paasche Air Eraser

The Air Eraser is not really an airbrush at all! It does not spray paint
but uses the airbrush principle to spray a stream of abrasive par-
ticles onto a surface, that erode away paint.

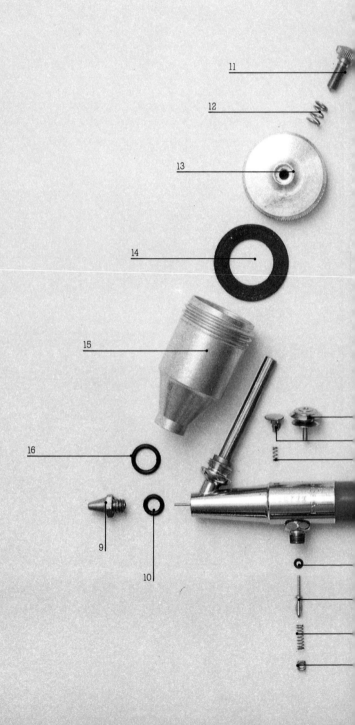

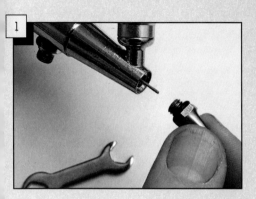

Strip-down

Remove the tip using the wrench that comes with the eraser for this job.

Remove the cup cover by unscrewing the cover of the powder cup and lifting it away.

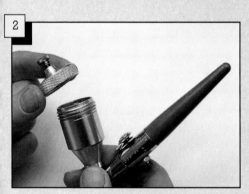

1

1 Body AE-30C
2 Spring A-143
3 Air adjuster H-156
4 Finger Lever AE-36
5 Valve washer A-52
6 Valve plunger H-21A
7 Valve spring A-22
8 Valve nut A-23A
9 Tip AE-34
10 'O' RING $\frac{3}{16}$in AE-43
11 Control screw AE-24
12 Spring H-134
13 Cover AE-23
14 Gasket AE-31
15 Cup AE-38
16 'O' ring $\frac{5}{16}$in AE-6

Take off the cup. Be careful when you lift off the cup, because powder is liable to spill out of the bottom.

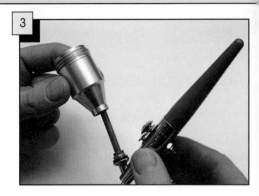

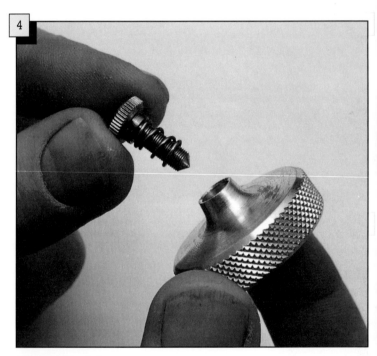

Remove the control screw and spring. This screw fits into the powder cup cover.

Take out the gasket in the cup cover. If the gasket is not in perfect condition the eraser will not work.

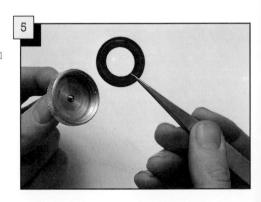

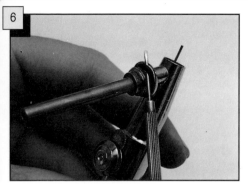

Remove the O-ring. If the O-ring on the powder tube assembly is damaged, squeeze the sides together then poke a screwdriver into the gap and ease it off.

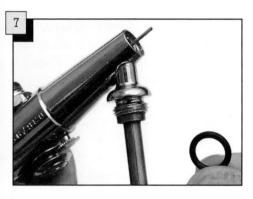

The O-ring sits in the groove on the powder tube assembly.

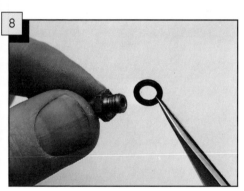

Take the O-ring off the tip easing it away from the tip with a pair of tweezers.

Paasche H3

This model is a low-priced, external-mix airbrush which works like a miniature spray gun. Many modelmakers use an H3 for painting their work. Its strip-down sequence can be used for the Paasche F1 and the airbrushes in the Badger 350 series.

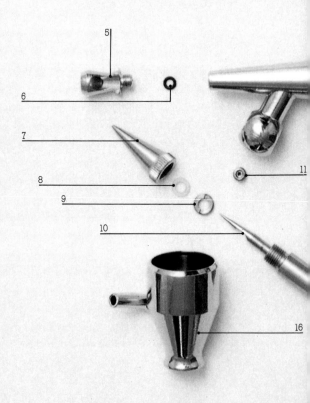

Strip-down

Loosen the set screw using a hexagonal key – the screw does not come out but should be given a quarter of a turn to unlock the needle.

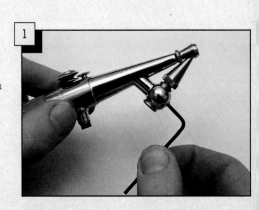

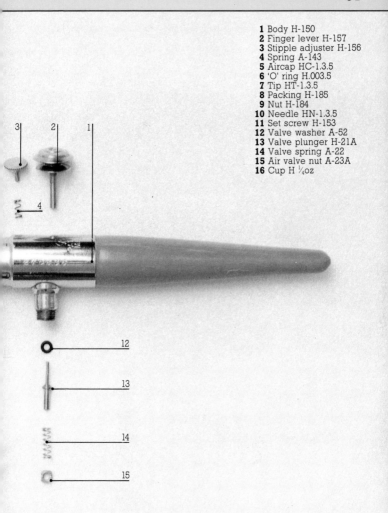

1 Body H-150
2 Finger lever H-157
3 Stipple adjuster H-156
4 Spring A-143
5 Aircap HC-1.3.5
6 'O' ring H.003.5
7 Tip HT-1.3.5
8 Packing H-185
9 Nut H-184
10 Needle HN-1.3.5
11 Set screw H-153
12 Valve washer A-52
13 Valve plunger H-21A
14 Valve spring A-22
15 Air valve nut A-23A
16 Cup H ¼oz

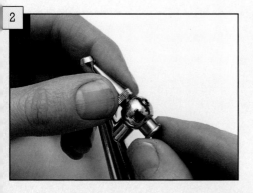

Pull back the needle by holding the lip on the rearward end, then unscrew the tip with your other hand.

Withdraw the needle. The hole in the edge of the needle is designed for the color to flow through.

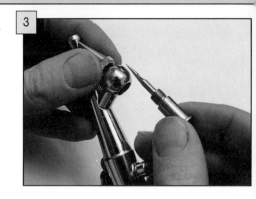

Unscrew the nut inside the tip. The screwdriver must be wide enough to span the central hole in the nut.

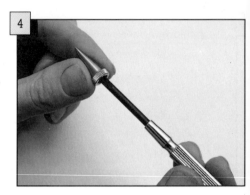

The packing is located inside the tip and is held in place by a nut.

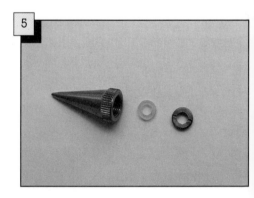

Unscrew the air cap. This should not be tight and will unscrew with finger pressure.

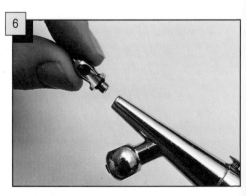

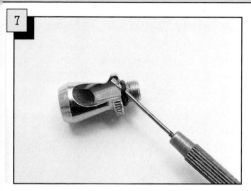

Remove the washer. This washer sits in a groove and you will need a fine screwdriver or a coarse needle to remove it.

Lock the nozzle. The nozzle can be locked in place with the hexagonal key. This is one extreme of its travel.

The nozzle will move as far as this in the other direction. Find the ideal position by trial and error.

Thayer and Chandler Model C

The Model C is a large-scale, double-action airbrush which can cope with a wide variety of uses. It can also be used with almost any type of paint. The order in that it is taken apart applies to all other Thayer and Chandler models.

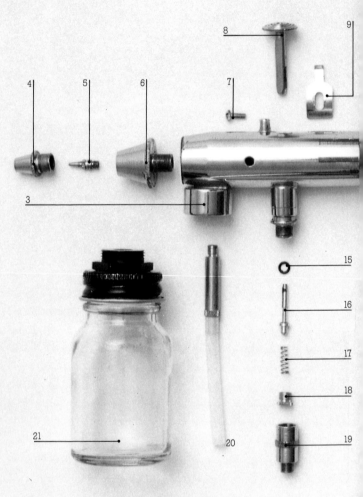

1 Handle
2 Needle
3 Body
4 Spray regulator
5 Tip
6 Head
7 Adjusting screw
8 Trigger
9 Back lever
10 Tube shank
11 Needle tube
12 Needle spring
13 Spring nut
14 Needle chuck

15 Valve washer
16 Valve plunger
17 Valve spring
18 Valve spring retainer
19 Hose adapter
20 Color tube
21 Jar

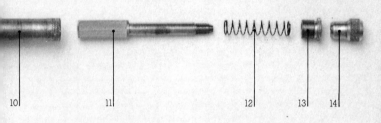

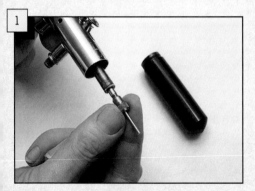

Strip-down

Unscrew the handle and then loosen the needle-locking nut.
Withdraw the needle easing it out of the airbrush body by drawing it backward carefully.

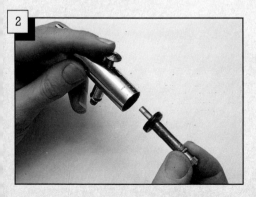

Unscrew the knurled end of the needle guide assembly and slide it out.

The needle guide assembly consists of four small components

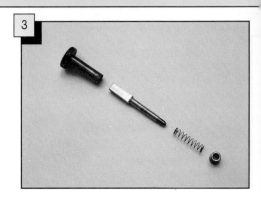

Remove the trigger and back lever. These parts should fall out when you turn the airbrush upside down.

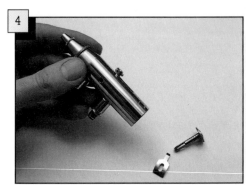

Remove the head. Use soft-jawed pliers to grip the head and then unscrew it with your fingers once it is loose.

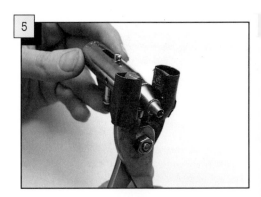

Undo the valve spring retainer. Use parallel-action pliers to grip the retainer and loosen it.

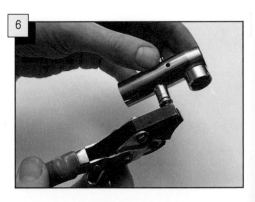

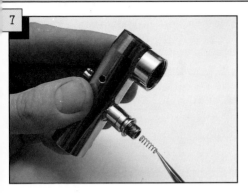

Take out the air valve spring using fine-pointed tweezers to draw out the spring if it sticks.

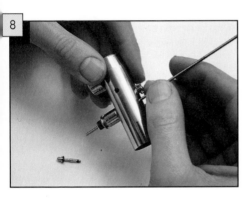

Remove the air valve pin. If it does not fall out, push it through from above with the blunt end of a needle.

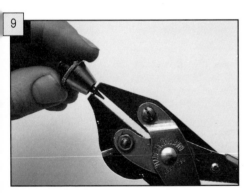

If you need to renew a damaged tip use flat-nosed pliers to loosen it. Push and turn the pliers at the same time so that they do not slide down the tip.

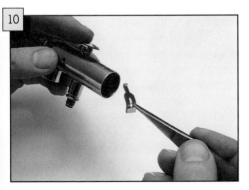

To refit the back lever that fits just behind the trigger, hold it with tweezers and thread it into the body. The tag at the top of the back lever sits against the trigger.

5
ACCESSORIES

Air hoses/Adapters and regulators/Air
cans/Car tires/Carbonic gas cylinders/
Compressor specification chart/
Air compressors/Compressor
maintenance/Distance guides/Airbrush
holders/Health and safety/Dust
masks/Goggles/Extractor fans/
Airbrush-compressor compatibility chart.

The airbrush is a complete item in itself but relies on accessories
such as air hoses and sources of air to function. The range of these
additional components is large, encompassing makeshift home-
made articles and highly sophisticated machinery. There is also a
variety of adapters and regulators that make it possible to use differ-
ent airbrushes on the same air hose and with a variety of compressors.
A chart in this chapter displays the compatibility of a large selection of
airbrushes with many of the compressors on the market.

Apart from the components that are essential for the airbrush, there
are a few for the airbrush user. The harmful substances in the paint
particles that linger in the air when you are spraying should be
filtered in some way so that you don't breathe them in.

Air hoses
There is a choice of materials from which air hoses are made. The
lightest in weight, and also the cheapest, are made from vinyl.
Although a vinyl hose's low weight will not restrict your movements, it
can easily be damaged, for instance by the careless use of an X-Acto
knife. The most common air hoses are made from rubber covered
with cotton or nylon braid. They are somewhat heavier than the vinyl
types but are much stronger — if you dropped a knife onto a braided
rubber air hose it would simply bounce off again.

The latest type of air hose is the curly coil variety. This design has a

conventional length of tube at the airbrush end and at the compressor end, with a springy coil of vinyl air hose in the middle. The coil unwinds to give additional lengths of hose when necessary, and then coils itself up again so that there is no unwanted air hose trailing on the floor.

Repairing an air hose is, to a large degree, pointless. You can, in theory, cut out a damaged portion and bridge the cut ends with connectors but it is much easier to buy a new one. Repairing a small cut with adhesive tape or glue is very difficult because the compressed air will soon open up the cut again.

Adapters and regulators

There are a number of screw threads in use by the various manufac-

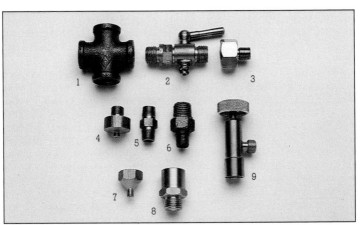

There is a large range of adapters available all with different functions (**above**). (**1**) A 4-way manifold that allows a number of airbrushes to be run from one compressor. (**2**) A tap that shuts off the air supply. (**3**), (**8**), and (**9**) can connect any air hose to any compressor. (**4**), (**5**) and (**6**) are hose connectors that enable two lengths of hose to be connected together. (**7**) An aerosol control valve that limits the air flow from a fully-charged aerosol.

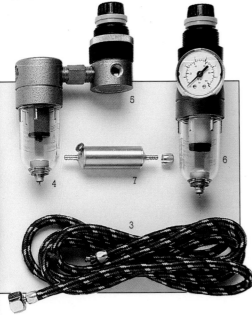

Many manufacturers of airbrushes also make their own air hoses (**left**), such as (**1**) DeVilbiss (**2**) Badger and (**3**) Paasche. These air hoses match up with their makers' airbrushes. Adding a filter (**4**) into the system will remove moisture from the air hose, while a pressure regulator (**5**) delivers a controlled pressure to the airbrush. Combined filter/regulators (**6**) are also available. Paasche make their own moisture trap (**7**) that fits into the air hose.

turers of airbrushes, compressors and air hoses. You will have no problem matching equipment made by the same manufacturer because they will use their own particular thread on the different pieces of equipment. However, if you have an air hose made by one maker and an airbrush made by another, the threads may well be of different sizes. Fortunately, you can buy adapters to connect different threads. Never try to force a reluctant fastening onto a thread that is slightly different because you may end up jamming the threads completely.

If you want to be able to switch quickly between different airbrushes during a job, it makes sense to use a two-way or multi-way adapter. This adapter is fitted to the outlet from the compressor and divides the compressed air between two or more take-off points. The more powerful compressors, such as are found in professional studios, can supply enough air for a number of airbrushes to be used at once. Nonetheless, it is still useful, even with a compressor that can cope with one airbrush only, to be able to switch between airbrushes during a job.

The other worthwhile accessory that fits to the compressor is the combined regulator and moisture trap. The more basic types of compressor do not have built-in regulators and so it is worth fitting one to give complete control over the output pressure of the compressor. You can then set the pressure at the optimum figure, or achieve special effects like lowering the output pressure to create a spatter. The moisture trap serves to remove any dampness from the compressed air before it can reach the airbrush. The accumulated moisture collects in a bowl – clear in some models – and should be drained off from time to time.

Another type of moisture trap is cylindrical in shape and fits into the length of air hose. This type can be emptied by unscrewing one end.

There is a wide choice of compressors (**below**), ranging from simple models, that will power one airbrush, to fully-automatic compressors with built-in storage tanks that can drive several airbrushes at once. Shown here are (**1**) the Simair SAC 110, (**2**) the Badger 180 Automatic, (**3**) the Simair SAC 330 and (**4**) the Dawson McDonald & Dawson D351 VM.

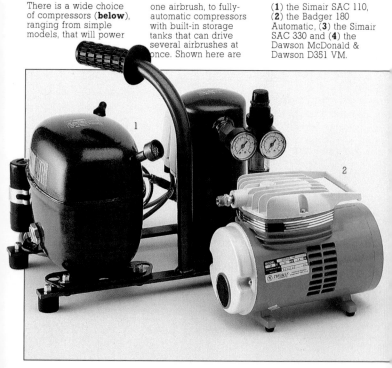

Sources of air

To a large extent, the quality of the air supply determines the potential quality of the work the airbrush produces. A good compressor can cost considerably more than the airbrush, but it is worth spending money on if you are going to do a lot of high-quality airbrush work.

Aerosol spray propellants The easiest way of getting started is to buy compressed gas in cans. Cans are suitable for occasional use and are, of course, completely portable. For regular use, aerosol spray propellants are expensive, but many professionals have a can in their kit in case their compressor goes wrong.

Propellants come in different sizes. The larger ones contain relatively more gas than the smaller ones do and so last longer; they generally work out cheaper to use per hour. A simple spray propellant will deliver a steadily reducing pressure to the airbrush as it empties out, but you can buy a pressure regulator that keeps the output pressure at a pre-set level until the pressure in the propellant falls below the pressure you have set. The gas in these propellants is generally not air, but carbon dioxide, or a gas such as Freon.

Car tires There are other supplies of compressed gas that do not involve the cost of a compressor. Perhaps the simplest substitute to use is a car tire. Car tires are bulky and often dirty, but they can be pumped up again if you have the time and energy, or access to a garage air hose. As with the spray propellant, the pressure drops off as the tire deflates, although a regulator will delay the falling-off in pressure. On the other hand, car tires are available cheaply from wrecker's yards and can be reinflated and reused any number of times.

Carbonic gas cylinders Carbon dioxide in cylinders has a variety of commercial applications. Carbonic gas cylinders are available in a range of sizes from specialist suppliers for use in welding equipment and for beer pumps. You will have to buy the cylinder and its contents in the first instance, but thereafter you exchange the empty cylinder for a full one and pay for the gas only, plus a handling charge. A pressure regulator is essential for use with a carbonic gas cylinder because the pressure of a fully-charged cylinder is far higher than the airbrush

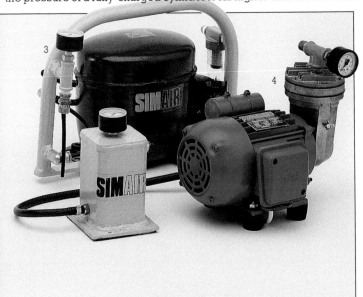

can handle. Most carbonic gas cylinder pressure regulators also include a gauge showing how much gas is left in the cylinder.

Air compressors

Diaphragm compressors Compressors come in a variety of types and with different outputs. The most expensive ones are suitable for delivering a steady pressure to a number of airbrushes simultaneously. At the other end of the scale is the direct diaphragm compressor. This design includes a diaphragm that is made to oscillate by the motor. Air is sucked in through a flap-valve as the diaphragm moves in one direction, and is then pumped out into the air hose when the diaphragm moves back again.

You can fit a pressure regulator to a diaphragm compressor. This regulator will control pressure being delivered to the airbrush, but will not eliminate the pulses of air that are caused by the action of the

TYPES OF COMPRESSORS

Like airbrushes, compressors come in a range of sizes and prices. It is important to buy a compressor which is suitable for the airbrushes you will be using and the type of work you are planning. A large professional compressor is designed to run continuously for

COMPRESSOR	TYPE	MOTOR W	HP
Dawson McDonald & Dawson			
D274	Oil-less diaphragm mounted on vertical receiver		
D245 S	Oil-less diaphragm		½
D189	Oil-less diaphragm		
2D/351 VM	Twin oil-less diaphragm		
D/351 VM	Oil-less diaphragm		$\frac{1}{12}$
De Vilbiss			
AFP	Foot pump		
Mini-compressor	Oil-less piston	44	$\frac{1}{12}$
ACA-1	Vertical piston	186	¼
Tuffy	Diaphragm	250	⅓
Twin Tuffy	Twin diaphragm	373	½

KEY: MOTOR W: watts, HP: horsepower
OUTPUT PSI: pounds per square inch
FAD/CFM: free air delivered/cubic feet per minute

diaphragm. This pulsing quality of the air flow is sometimes notice-able in delicate airbrush work, and for this reason many artists prefer not to use a diaphragm compressor.

Storage compressors All the more advanced compressors incorpor-ate storage tanks. The tank acts as a reservoir for compressed air, eliminating the pulsing effect of the direct diaphragm compressor.

The simplest storage compressors are driven by small electric motors that operate continuously when the compressor is switched on. Because simple storage compressors are not built to heavy duty specifications, they are prone to overheating and need to be rested at frequent intervals.

Piston compressors The next step up in the compressors is the small piston-operated design. This type uses its electric motor to drive a piston that compresses the air. In some models, the piston is both lubricated and cooled by oil, and comes with a sight-glass or a

long periods whereas a lightweight, low-priced compressor would overheat if it were used for a full working day. Some of the large-scale airbrushes and the smaller sprayguns which are covered in this book need a medium or large compressor to provide the amount of air which they require.

OUTPUT PSI	FAD/CFM	COMMENTS
45	1.2	Tank-mounted compressor for small studio use. Suitable for up to four airbrushes.
30	2.25	Medium-size compressor with a high output. For use with small spray guns.
30	1.5	Medium-size compressor suitable for long periods of continuous duty.
30	0.6	Two-stage compact compressor, suitable for long periods of use. For 2 airbrushes.
30	0.3	Compact, light-weight, suitable for long periods of use. For 1 airbrush.
40		Old-fashioned type. Main advantage no noise. For occasional use. Can be used anywhere.
30	0.3	Small, portable. Very noisy. Can only be operated for very short periods before becoming too hot. For 1 airbrush.
30	0.23	Traditional type. Bulky but very reliable. Models are still running after 30 years.
30	1.9	Powerful but very noisy.
35	3.1	Very powerful but very noisy.

dipstick for checking the amount of oil in the compressor. The simplest compressors of this type run continuously and may overheat if they are run for excessive periods without a rest.

Automatic compressors The compressor at the top of the range is the fully automatic type. The difference between fully automatic compressors and the other models is that the compressor delivers air into the reservoir until it reaches a pre-set pressure, and then shuts off. The pressure in the reservoir is greater than that which the regulator delivers to the airbrush. If the airbrush is kept running the pressure in the reservoir will drop. Then, when the pressure falls sufficiently, the motor cuts in again and refills the reservoir. For this reason, the motor is not running continuously and so should not overheat.

Types of Compressors
Continued

COMPRESSOR	TYPE	MOTOR W	HP
Morris & Ingram Micon	Diaphragm	190	$\frac{1}{5}$
Badger 180-1	Diaphragm		$\frac{1}{12}$
Badger 180E	Diaphragm		$\frac{1}{12}$
15H	Oil-reciprocating horizontal piston ultra quiet	95	$\frac{1}{8}$
M130	Oil-reciprocating horizontal piston ultra quiet	170	$\frac{1}{4}$
50G	Oil-reciprocating horizontal piston ultra quiet	340	$\frac{1}{2}$
Royal Sovereign Jun-Air	Oil-reciprocating horizontal piston ultra quiet	340	$\frac{1}{2}$
Gemini	Oil-reciprocating horizontal piston ultra quiet		$\frac{1}{6}$
Simair SAC 330	Oil-reciprocating horizontal piston ultra quiet	130	$\frac{1}{5}$
SAC 110/2	Oil-reciprocating horizontal piston ultra quiet	250	$\frac{1}{3}$
SAC 110/3	Oil-reciprocating horizontal piston ultra quiet	385	$\frac{1}{2}$
SAC 110/4	Oil-reciprocating horizontal piston ultra quiet	470	$\frac{2}{3}$
SAC 110/5	Oil-reciprocating horizontal piston ultra quiet	470	$\frac{2}{3}$

KEY: MOTOR W: watts, HP: horsepower
OUTPUT PSI: pounds per square inch
FAD/CFM: free air delivered/cubic feet per minute

Compressor maintenance Unfortunately, compressors tend to be ignored and some airbrush artists never actually see their compressor from one year to the next unless it stops working. Often the compressor is kicked out of sight under the table where it becomes surrounded by general debris. Try to inspect your compressor before each spraying session. Make sure that no stray pieces of paper or card have fallen onto it, because these will reduce the circulation of air around the compressor and make overheating more likely.

If there is an oil level sight-glass or dipstick, check the oil level and, if necessary, top it up with the brand of oil recommended by the manufacturer.

Make sure that the moisture trap in the reservoir is drained regu-

OUTPUT PSI	FAD/CFM	COMMENTS
30	0.6	Small, continuous-running compressor for intermittent use. For 1 airbrush.
30	6	Small, continous-running compressor. For 1 airbrush.
30	.6	Small, intermittent-running compressor controlled by a microswitch in head.
75	.3	Suitable for 1 airbrush.
120	.8	Suitable for 2 airbrushes.
120	1,3	Suitable for 4 airbrushes.
120	1.8	Suitable for 5 airbrushes.
50	.6	Suitable for 2 airbrushes.
60	.75	Suitable for 1 airbrush
100	1.1	Suitable for 2 airbrushes.
100	1.5	Suitable for 3 airbrushes.
100	1.8	Suitable for 4 airbrushes.
100	2.1	Suitable for 5 airbrushes.

larly. If it is not kept clear, moisture may find its way into the airbrush and onto your work.

Also keep the air intake filter clean. The instruction book with the compressor will show you how to reach the intake filter. If it gets clogged, the compressor will not be able to suck in enough air and the pressure of air being delivered to the airbrush will fall.

These routine checks will give your compressor the best chance of giving you good service. Major repair work on compressors should be left to a specialist unless you are familiar with working on electric motors and pumps.

Airbrush holders

When you are in the middle of an artwork it is often convenient to be able to put the airbrush down, maybe to allow you to mix some more fluid. These inactive periods when the airbrush still has paint in it should be kept as brief as possible because some kinds of color will dry inside the airbrush in a very short space of time. However, you can buy airbrush holders that will hold the airbrush in a horizontal position so that color does not run out of the color cup. If you have space at the side of your work table, mount an airbrush stand in a position where the air hose can run to the compressor without getting in your way.

It is always useful to be able to put the airbrush out of harm's way when it is not in use. There are airbrush holders on the market but it is a simple matter to make your own. An ideal way of making an airbrush holder is to screw a threaded eye, obtainable from most hardware stores, into the side of your work table or into the edge of a shelf. Similarly, you can make a serviceable holder for your air hose from a spring-steel clip, of the type used to hold tools in place on workshop walls. Just screw the clip into a handy place where the trailing hose will not get in your way and snap the free end of the hose into the clip

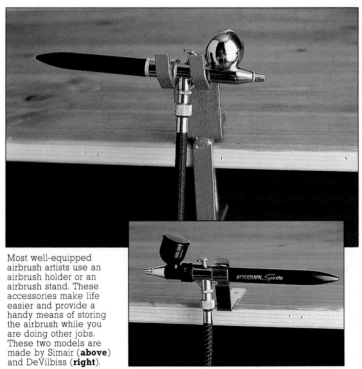

Most well-equipped airbrush artists use an airbrush holder or an airbrush stand. These accessories make life easier and provide a handy means of storing the airbrush while you are doing other jobs. These two models are made by Simair (**above**) and DeVilbiss (**right**).

when you have disconnected it from the airbrush after a spraying session.

Distance guides

Another airbrush accessory that some artists favor is the adjustable distance guide. This device fastens to the airbrush and has an adjustable arm that can be used to fix the distance from the airbrush to the surface you are working on. Many purists regard guides as unnecessary, claiming that with practice the skilled artist should be able to control the position of the airbrush with accuracy. There is also the practical disadvantage that the end of the distance guide will trail across the paper and may smudge any color that it touches. On the other hand, a distance guide will help you to spray lines of even width and you can prevent smudging by giving a little thought to the order in which you spray the different areas of the surface. If you work systematically from left to right and from top to bottom you will avoid trailing the end of the distance guide through areas of color that are still wet.

Health and safety

Airbrushing is usually a hazard-free activity, but the airbrush is designed to blow tiny particles of color out at high pressure with the result that invisible traces of color tend to get everywhere. Some of the colors contain toxic substances. For example, some yellow colors contain cadmium. This substance can be found in small quantities in the human body, but it causes illness if it is inhaled in the form of vaporized paint. Many artists have been surprised by the amount of stray paint that is generated during an airbrushing session. If there is an extractor fan running in your studio, look at its housing after you have finished work and you will see substantial deposits of the colors you have just been using.

Dust mask One of the easiest ways of cutting down the danger from breathing in harmful substances is to wear a dust mask. The simplest kind consists of a metal frame threaded onto an elasticated strap. Absorbent pads of material fit into the frame that is flexible enough to be molded to the contours of your nose and mouth. The absorbent pads come in packs, so you can throw away the pad when it starts to get clogged up — you can tell that this is the case when there is a coating of color on the outside surface of the pad.

Goggles Some paints can also irritate your eyes and so wearing goggles is a useful safety precaution. You can buy goggles that cover the eyes but still allow ventilation, so that the eyes do not become too dry during a period of work.

Extractor fans You can minimize health risks and also keep the studio clean and well ventilated by fitting an extractor fan. Some types fit into the thickness of the wall and others are designed to fit into a hole cut into a pane of glass. You will need to fit a fan with an electric motor, not the kind sometimes found in bathrooms that simply blows around when drafts occur. Some extractor fans have different speed settings. A multispeed model has the advantage that you can use a slower, quieter speed when you are doing more delicate work, and an even slower speed to clear the air after you have finished spraying.

It may not be possible to fit an extractor fan if, for instance, your studio does not have an outside wall. In this case, a recirculating oven hood will do the job. Hoods of this kind contain electrically-driven fans that suck in air from the room, pass it through filters and then send the purified air back into the room. The filter mesh or charcoal filter material should be removed periodically and either cleaned or renewed.

AIRBRUSH – COMPRESSOR COMPATIBILITY

Choosing the right compressor is as important as picking the right airbrush. Compressors span a wide range of prices and range from small models which will power a single airbrush to large designs that have the output to drive several airbrushes at once. If you are

COMPRESSOR	Badger 350-F	350-M	350-H	200 EX	100 GXF	100 XF	100 II
Dawson McDonald & Dawson D274	•	•	•	•	•	•	•
D245 S	•	•	•	•	•	•	•
D189	•	•	•	•	•	•	•
2D/351 VM	•	•		•	•	•	•
D/351 VM				•	•	•	•
De Vilbiss A.F.P.	•	•		•	•	•	•
Mini-Compressor	•	•		•	•	•	•
ACA-1	•	•		•	•	•	•
Tuffy	•	•	•	•	•	•	•
Twin Tuffy	•	•	•	•	•	•	•
Morris & Ingram Micon	•	•	•	•	•	•	•
Badger 180-1	•	•		•	•	•	•
Badger 180 E	•	•		•	•	•	•
15H	•	•		•	•	•	•
M130	•	•	•	•	•	•	•
50G	•	•	•	•	•	•	•
Royal Sovereign Jun-Air	•	•	•	•	•	•	•
Gemini	•	•	•	•	•	•	•
Simair SAC 330	•	•	•	•	•	•	•
SAC 110 2	•	•	•	•	•	•	•
SAC 110 3	•	•	•	•	•	•	•
SAC 110 4	•	•	•	•	•	•	•
SAC 110 5	•	•	•	•	•	•	•

just beginning to airbrush, it is still worthwhile buying a good-quality compressor because a very cheap and basic model makes airbrushing more difficult than a higher-quality compressor does, which will produce a smoother flow of compressed air.

	100 LGXF	100 LGIL	100 LGHD	150 XF	150 IL	150 HD	400 Touch-up Gun	Conopois	De Vilbiss Super 63A	Super 63E	Sprite Major	Sprite
	•	•	•	•	•	•	•	•	•	•	•	•
	•	•	•	•	•	•	•	•	•	•	•	•
	•	•	•	•	•	•	•	•	•	•	•	•
	•	•	•	•	•	•		•	•	•		•
	•	•	•	•	•	•		•	•	•		•
	•	•		•	•			•	•	•		•
	•	•		•	•			•	•	•		•
	•	•	•	•	•	•		•	•	•		•
	•	•	•	•	•	•	•	•	•	•	•	•
	•	•	•	•	•	•	•	•	•	•	•	•
	•	•	•	•	•	•		•	•	•		•
	•	•	•	•	•	•		•	•	•		•
	•	•	•	•	•	•		•	•	•		•
	•	•	•	•	•	•		•	•	•		•
	•	•	•	•	•	•		•	•	•	•	•
	•	•	•	•	•	•	•	•	•	•	•	•
	•	•	•	•	•		•	•	•	•	•	•
	•	•	•	•	•	•		•	•	•		•
	•	•	•	•	•	•		•	•	•	•	•
	•	•	•	•	•	•	•	•	•	•	•	•
	•	•	•	•	•	•	•	•	•	•	•	•
	•	•	•	•	•	•	•	•	•	•	•	•
	•	•	•	•	•	•	•	•	•	•	•	•

Airbrush-Compressor Compatibility
Continued

COMPRESSOR	De Vilbiss MP C-C	MP1-1	MP 2-2	MP 3-3	Hohmi Y3	Iwata HP-A	HP-B
Dawson McDonald							
D274	•	•	•		•	•	•
D245 S	•	•	•	•	•	•	•
D189	•	•	•		•	•	•
2D/351 VM					•	•	•
D/351 VM					•	•	•
De Vilbiss							
A.F.P.					•	•	•
Mini-Compressor					•	•	•
ACA-1					•	•	•
Tuffy	•	•	•	•	•	•	•
Twin Tuffy	•	•	•	•	•	•	•
Morris & Ingram							
Micon					•	•	•
Badger 180-1					•	•	•
Badger 180 E					•	•	•
15H					•	•	•
M130					•	•	•
50G	•	•	•		•	•	•
Royal Sovereign							
Jun-Air	•	•	•	•	•	•	•
Gemini					•	•	•
Simair							
SAC 330					•	•	•
SAC 110 2	•	•	•		•	•	•
SAC 110 3	•	•	•	•	•	•	•
SAC 110 4	•	•	•	•	•	•	•
SAC 110 5	•	•	•	•	•	•	•

HP-C	E-1	E-2	SB	BC	BE-1	BE-2	Olympos HP-100A	HP-100B	HP-100C	SP-A	SP-B
•	•	•	•	•	•	•	•	•	•	•	•
•	•	•	•	•	•	•	•	•	•	•	•
•	•	•	•	•	•	•	•	•	•	•	•
•	•	•	•	•	•	•	•	•	•	•	•
•	•	•	•	•	•	•	•	•	•	•	•
•	•	•	•	•	•	•	•	•	•	•	•
•	•	•	•	•	•	•	•	•	•	•	•
•	•	•	•	•	•	•	•	•	•	•	•
•	•	•	•	•	•	•	•	•	•	•	•
•	•	•	•	•	•	•	•	•	•	•	•
•	•	•	•	•	•	•	•	•	•	•	•
•	•	•	•	•	•	•	•	•	•	•	•
•	•	•	•	•	•	•	•	•	•	•	•
•	•	•	•	•	•	•	•	•	•	•	•
•	•	•	•	•	•	•	•	•	•	•	•
•	•	•	•	•	•	•	•	•	•	•	•
•	•	•	•	•	•	•	•	•	•	•	•
•	•	•	•	•	•	•	•	•	•	•	•
•	•	•	•	•	•	•	•	•	•	•	•
•	•	•	•	•	•	•	•	•	•	•	•
•	•	•	•	•	•	•	•	•	•	•	•
•	•	•	•	•	•	•	•	•	•	•	•

Airbrush-Compressor Compatibility
Continued

COMPRESSOR	Olympos SP-C	Paasche F-1	H-1	H-3	H-5	VJR	V-1	VLS-1
Dawson McDonald								
D274	•	•	•	•	•	•	•	
D245 S	•	•	•	•	•	•	•	
D189	•	•	•	•	•	•	•	
2D/351 VM	•	•	•	•			•	•
D/351 VM	•					•	•	
De Vilbiss								
A.F.P.	•	•	•			•	•	•
Mini-Compressor	•	•	•			•	•	•
ACA-1	•	•	•	•		•	•	•
Tuffy	•	•	•	•	•	•	•	•
Twin Tuffy	•	•	•	•	•	•	•	•
Morris & Ingram								
Micon	•	•	•	•	•	•	•	•
Badger 180-1	•	•	•	•	•	•	•	•
Badger 180 E	•	•	•	•	•	•	•	•
15H	•	•	•	•		•	•	•
M130	•	•	•	•	•	•	•	•
50G	•	•	•	•	•	•	•	•
Royal Sovereign								
Jun-Air	•	•	•	•	•	•	•	•
Gemini	•	•	•	•	•	•	•	•
Simair								
SAC 330	•	•	•	•	•	•	•	•
SAC 110 2	•	•	•	•	•	•	•	•
SAC 110 3	•	•	•	•	•	•	•	•
SAC 110 4	•	•	•	•	•	•	•	•
SAC 110 5	•	•	•	•	•	•	•	•

VLS-3	VLS-5	AB Turbo	**Rich** AB-100	AB-200	AB-300	**Thayer & Chandler** Model A	Model AA	Model C	Model E	Model G	**Air Duster**
•	•	•	•	•	•	•	•	•	•	•	•
•	•	•	•	•	•	•	•	•	•	•	•
•	•	•	•	•	•	•	•	•	•	•	•
•		•	•	•	•	•		•			
			•	•	•	•		•			
			•	•	•	•		•			
			•	•	•	•		•			
•			•	•	•	•			•		
•	•	•	•	•	•	•	•	•	•	•	•
•	•	•	•	•	•	•	•	•	•	•	•
•			•	•	•	•	•		•		
•			•	•	•	•	•		•		
•			•	•	•	•	•		•		
•			•	•	•	•	•		•		
•		•		•	•	•	•		•	•	
•	•			•	•	•	•		•	•	•
•	•	•	•	•	•	•	•	•	•	•	•
•	•	•	•	•	•	•	•		•	•	•
•	•	•	•	•	•	•	•		•	•	
•	•	•	•	•	•	•	•	•	•	•	•
•	•	•	•	•	•	•	•	•	•	•	•
•	•	•	•	•	•	•	•	•	•	•	•
•	•	•	•	•	•	•	•	•	•	•	•

6
MEDIA AND SUPPORTS

Characteristics of media/Suitability/
Watercolor/Gouache/Ink/Acrylic/Oil/
Loose masks/Liquid masking/Masking
film/Masking tape/Drawing
instruments/Scalpels/Curves/Rulers/
Boards/Watercolor paper/Paper/
Acetate/Use and media suitability

In artists' terminology, a medium is any kind of paint, dye or other coloring agent that is used to color a support, or surface. From the airbrush artist's point of view, almost any kind of color can be sprayed onto a surface, as long as it is mixed to the right consistency and does not contain large particles that might clog the passages inside the airbrush. There are some media and also some solvents that can damage non-metallic components inside the airbrush. For this reason, it is generally best to stick to the most common media. Another reason for doing so it that there is a lot of information available about the suitability of these media for airbrushing whereas there is not for the less common media. If you decide to experiment with an unusual medium, the manufacturer of the medium should be able to advise you how to dilute it, what solvent to use to clean the airbrush and whether it will react unfavorably with any other media or surfaces.

Characteristics of media
There are two basic types of media — those that contain dyestuffs and those that contain pigment. In the first kind, the dyestuff dissolves completely in the fluid to form an evenly-colored liquid. In the second variety, the colored particles in the fluid are not dissolved, but they are extremely small and will not clog an airbrush if the medium is mixed correctly. However, this type does have a slight scouring action as the particles pass through the airbrush nozzle, causing a certain amount of wear in the nozzle.

Media also vary in their resistance to fading. Some colors are described as fugitive, which means that they have a natural tendency to fade. In general, fading takes place more quickly when the artwork is exposed to bright light, particularly sunlight, and occurs faster with inferior paints or Student's quality paint. However, even when the artwork is kept covered, fugitive colors will slowly fade.

Media that have been developed especially for airbrushing usually have short drying times, which means that you can achieve a lot more in one spraying session. Other media, particularly oil paints, do not dry quickly and need to be left for long periods before the next color can be applied.

When the medium has dried, the surface may not be able to withstand rough handling. Finishes that are delicate and that need protection can be sprayed with a fixative that doesn't affect the color but acts as a clear barrier. One common fixative is gum solution. The gum

dries on the artwork without damage to the colors underneath. However, it will also dry inside the airbrush if it is not flushed out immediately after use.

Suitability

The possibilities for experimenting with different media, colors and surfaces are endless. Before trying out an unconventional medium, it is wise to check that the recommended medium does in fact work before you start to spray that medium through your airbrush. Apply a little of the medium to a piece of scrap metal, leave it to dry, and then brush on some solvent. If it softens the medium so that it can be washed away with water, you should be safe in the knowledge that you will be able to clean out your airbrush. If the solvent does not do the trick, either experiment with a different solvent or look for another medium.

Some types of medium also require the surface to be primed before you start spraying. This may be because the medium will rot the surface or react unfavorably with it, or because the surface is very porous and a lot of the medium would soak into it. For example, canvas is porous and needs to be sprayed with a coat of sealant before you apply the color, and paper needs to be stretched before you spray watercolor onto it. Again, the best approach is to experiment with a spare piece of the material in question before beginning the main artwork. Most manufacturers of surfaces and media have information departments who are happy to advise you on the suitability of the ideas you have in mind.

Watercolor

Many airbrush artists like to work with watercolor because of the delicate effects that can be achieved with this medium. There are now watercolors made especially for airbrush use sold in liquid form, ready-diluted to the ideal consistency.

For the airbrush user, the important feature of watercolor is that it is clear. Working in the usual way, from light to dark, when a layer of watercolor is sprayed onto an existing color, the underlying color will still show through and affect the finished result. By spraying fine coats of watercolor over a base color, it is possible to control the final shade with a great degree of accuracy.

Watercolor is commonly sold in the form of cakes made of dried powder, or else as thick paste in pans or half pans or in semi-fluid form in tubes. All of these kinds of watercolor need to be diluted to make them suitable for use in the airbrush. Distilled water is the ideal liquid with which to dilute watercolor, because it does not contain any impurities that might cause the characteristics of the watercolor to change.

It is possible to mix two or more watercolors together to produce shades that are not available separately. If you are mixing colors together, it is best to check that all the colors are colorfast, because mixing one colorfast shade with a shade that is not will result in a hybrid color that is likely to deteriorate over a period of time.

Gouache

Gouache, sometimes called designer's gouache, is a form of watercolor that is particularly suitable for use in airbrushes. It differs from watercolor in that the pigment has precipitated chalk added to it before being bound with gum arabic. It is soluble in water, so does not need special solvents if it is accidentally left to dry inside the airbrush. There is a wide range of colors available in gouache, which can

be mixed together to produce intermediate shades.

Some ranges of gouache are completely opaque whereas others range from almost opaque to completely clear. This quality is useful for achieving special effects with the airbrush — if the exact shade of color is not important, you may be able to choose between an opaque color and a similar clear color, depending on whether you want the underlying color to show through. Another factor to consider is the staining characteristic of any color that you are spraying on top of another. If the color underneath tends to stain, it may bleed through and discolor the shade that you are spraying over it.

Gouache is sold in concentrated form in tubes or cakes. For airbrush use, it needs to be diluted to approximately the thickness of milk. If it is too thick, gouache will not spray evenly but tends to produce a spattery effect; too thin, and the result will be a blotchy, uneven layer of paint.

When mixing gouache, add water a little at a time to the gouache until the consistency is correct. If you are altering the basic color of the gouache, there are white and black gouaches available that can be mixed with the basic color to produce lighter or darker tones. Permanent white will reduce the basic color and give a high degree of opacity, whereas zinc white, as well as reducing the color also produces a clean, lightfast result. When lowering the tonal value of a color by adding black, you can choose the exact type of black to give the result you want. Jet black gives a deep, rich velvet effect but if you mix jet black with white to make gray, the color you end up with is a bluish gray. Lamp black does not have quite the same blackness as jet black does when mixed with colors, but gives cooler grays when mixed with white.

Paints manufactured by different companies often have different properties. Some manufacturers indicate these properties by codes. Below are paint codes as used by Winsor and Newton for gouache.

Opacity
- **O** Absolutely opaque
- **R** Moderately opaque but not over dark colours
- **P** Partly clear
- **T** Completely clear
- ⊙ Hazardous metal contents

Permanence
- **AA** Very permanent
- **A** Permanent, but not as much as the above
- **B** Fairly permanent
- **C** Fugitive

Staining
- **N** Non-staining
- **M** Moderately stable but not with light colors
- **St** Stains to some extent
- **SS** Strongly staining

Gouache

Ink

There are two main classifications of inks — waterproof and non-waterproof. Greater care is needed when non-waterproof inks are used for airbrushing because if they are allowed to dry inside the airbrush they leave deposits that are sometimes very difficult to remove. If you are spraying with waterproof ink, make sure that the airbrush is never allowed to stand before it has been thoroughly flushed through to remove all traces of ink. Non-waterproof inks, on the other hand, are designed to be removed by soaking in water and so do not leave deposits that would require special solvents.

There are not as many different shades available in ink as there are in watercolor or gouache, but inks can be mixed together to provide intermediate colors. Mixing a waterproof ink with a non-waterproof one will result in an ink that still has some waterproof qualities; while it will not resist accidental spashes of water on the finished artwork as effectively as a pure waterproof ink will, it will still clog up the airbrush if it is allowed to stand inside it when you have finished a spraying session.

Acrylic

Acrylic paints are made from a synthetic resin similar to that used in the manufacture of plexiglass, polyethylene kitchen equipment, false teeth and the heels of shoes. The paints can be sprayed in the same way as other colors can, but dry very quickly to form a plastic coating that is resistant to water. For this reason, if acrylics dry inside the airbrush, special solvents will be needed to remove the residue.

Acrylics generally come in tubes and need to be diluted to roughly the consistency of milk for airbrush use. The container for the paint will say whether water can be used to dilute the paint or whether a special diluent needs to be mixed with the acrylic. Thinly diluted acrylic can produce the same transparency of color found in watercolor. As well as tubes of acrylic, you can buy larger quantities in jars. If you plan to spray only a small area with acrylic paint, it is worth finding out whether it is possible to buy the color you want in a small

Ink

quantity. Some colors are available in commercial quantities only and another medium, that is available in more economical quantities, such as ink or gouache, might well produce the effect you want.

The effect of using acrylic paint is a rich, intense color that stands up well to wear and tear. Acrylic is worthwhile considering if you are spraying large areas and need a finish that is tough and long-lasting.

Oil paint

Oil paints have the attraction that they are available in an almost unlimited range of colors, but they have a number of drawbacks. Firstly, oil paints have not been designed to be quick-drying and so any airbrush work, apart from a uniform spraying with one color, will entail leaving the work for a long time while the paint dries.

Oil paint as supplied for use with paintbrushes is too thick to pass through an airbrush, although some oils can be diluted with turpentine and others require special preparations to dilute them. Thinning the paint with turpentine can be tedious, because you need to mix the two together especially thoroughly to make sure that the turpentine has mixed evenly with all of the paint. If you are diluting more than a very small quantity of oil paint, it may be worth buying a paint-mixing attachment that fits into the chuck of an electric drill and makes short work of producing an even mixture. Add the turpentine a little at a time and keep checking the consistency until it has reached the milky thickness that is best for airbrush use. You can speed the drying time of oil paints by adding a fixative or drying oil to it but these tend to change the color slightly. After you have finished spraying with oils, flush the airbrush through with turpentine and then clear the turpentine away by spraying clean meths through the airbrush.

Masking

Loose masks A loose mask is any kind of mask that does not stick to the surface on which you are spraying. For instance, if you used a ruler to cover part of the paper while you sprayed a straight line against the edge of the ruler, you could call the ruler a loose mask.

Normally, loose masks are cut to the particular shape you require. Since a loose mask is not stuck to the surface, there will be a tendency for the edge between the mask and the sprayed area to be slightly blurred instead of sharply defined. This problem can be overcome by placing small weights or coins near the edge of the mask to hold it in place. Depending on the surface you are using, you may be able to stick the mask down, using a light adhesive that enables the mask to be peeled off again afterward. Some kinds of illustration do not require absolutely sharp edges, in which case a loose mask laid lightly on the work may produce just the kind of soft edge between colors that is wanted.

A transparent loose mask, such as a sheet of clear acetate, can be used where a gradual build-up of color is needed. After you have sprayed one layer of color, you can move the mask back slightly to expose more of the surface and then spray another layer. Providing you keep the mask clean you will be able to see the results of your spraying and make fine adjustments to get the desired result.

Loose masking provides unlimited scope for experimentation and special effects. Almost anything that can be held between the airbrush and the surface can be used as a mask. For instance, you can create a soft edge to a sprayed area by tearing the edge of a piece of paper to give a rough line to use as a mask; moving the paper to and fro slightly as you are spraying will blur the edge to a greater degree. For a really soft-edged loose mask, use a cotton ball pulled out into a

strip and held in place by small weights so that it does not blow away.

For work that involves lettering, sheets of instant lettering provide ideal masks. If, for example, you want the lettering to be in green on a red background, spray your surface in green first, then rub down the letters as lightly as possible but making sure that they have been properly rubbed off the backing sheet. Once the letters have been rubbed down, spray the surface in red, wait for the color to dry and peel the lettering away, leaving the green letters showing against the red background. Similar effects can be achieved using any characteristically shaped object, such as a leaf, coin or feather.

Liquid masking Liquid masking materials are made from a rubber compound that is held in liquid form until it is exposed to the air. When air meets the liquid masking, the liquid evaporates and the rubber solution dries on the paper or surface. For this reason, liquid masking tends to dry on the brush you are using to apply it with, which makes it rather tiresome to use unless you apply it quickly and are masking a small area only.

The other problem with liquid masking is that it can discolor some surfaces and may also stick to some paints, making it difficult to peel off the mask without pulling away part of the paint. Liquid masking has its uses, particularly in photographic retouching because photographic printing paper is not very absorbent and so the masking can be removed without damage to either the surface of the paper or to the colors of the print.

Masking film The type of mask most often used in airbrush work is the kind of film that has a self-adhesive backing. You can buy this film either in loose pieces or in a roll. The adhesive backing of the film is protected by a layer of paper that can be peeled off when the film is needed. The adhesive used on masking film is designed to peel off easily so that the film does not damage the surface or any layers of color that have already been sprayed. If you are in any doubt about the risk of damaging a particularly soft surface or delicate color, always experiment with a piece of surface before going on to the main piece of work. If there is going to be a risk of spoiling your work with masking film, you may have to use a loose mask instead.

With practice, you can cut masking film in position on the surface to be sprayed without damaging the surface. This has the advantage that when you want to mask two adjacent areas that are going to be sprayed in different colors, you can mask the total area, cut the mask between the two sections and then remove the first section of the mask, leaving the other one in place. Spray the uncovered section, then, when the color has dried, you can replace the first piece of film so that it fits exactly against the second piece, which is still stuck down, and then remove the second piece to give a perfect edge between the two colors.

Self-adhesive masking film has limitations when you are working with very large areas, because it may not be possible to reuse the film if it has been cut to an unusual shape, and you will have used up a lot of film on one masking job. In situations like this, it is often more economical to cover the bulk of the area to be masked with ordinary paper, stopping just short of the edge, and to use masking film just wide enough to hold the masking paper in place.

Masking tape Masking tape can also be used to provide a sharp edge for spraying against. It has one advantage over masking film — it can be laid either in straight lines, or with the outside edge forming a curve that you can shape as you are sticking the tape down. So if you wished to mask, for example, the windows of a model railway carriage before spraying the bodywork, you could use masking tape and

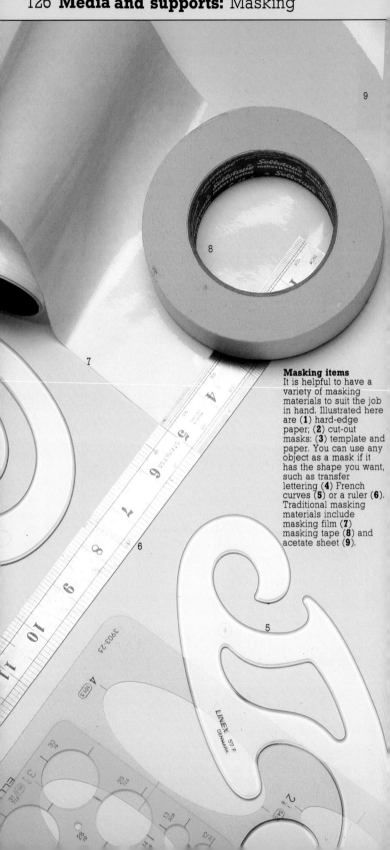

Masking items
It is helpful to have a variety of masking materials to suit the job in hand. Illustrated here are (**1**) hard-edge paper; (**2**) cut-out masks: (**3**) template and paper. You can use any object as a mask if it has the shape you want, such as transfer lettering (**4**) French curves (**5**) or a ruler (**6**). Traditional masking materials include masking film (**7**) masking tape (**8**) and acetate sheet (**9**).

1

2

50g

5g

3/16 R

2.000

2

20g

3

4

form curved edges with the mask without having to use an X-Acto knife, by curving the tape to stretch the outside edge as you stick it down.

Implements
Drawing instruments A set of basic drawing instruments will often come in useful for marking out work that is going to be airbrushed. If your work involves drawing lines of an accurate width, it is worth investing in a set of technical pens such as Rotring or Rapidograph. These pens have nibs that are in the form of tubes, so that when the pen is held at right-angles to the paper a line of exactly constant width is produced. You will probably need to buy only one pen handle and a few heads to be able to cope with most situations. Each head contains a nib of a specific width, and a reservoir to contain the ink or color you are using. The reservoir can be refilled from an eye dropper and the heads are easily cleaned in solvent or water when they have been used, or between color changes.

Another useful instrument is a divider. Even non-technical artists use a divider for transfering dimensions from a rough sketch to the final artwork, or for marking the same dimension a number of times on the artwork. When a divider is used carefully, there need not be any noticeable mark on the surface where the points of the divider have been placed.

If your work entails reproducing a drawing in either a larger or smaller scale, a pantograph makes life a lot easier and is much

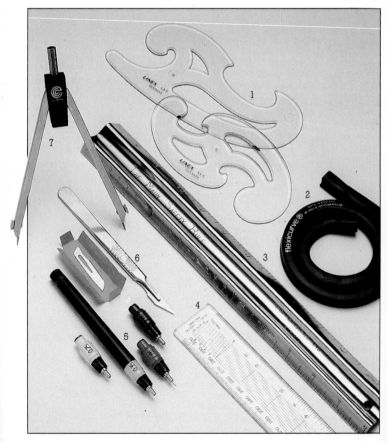

cheaper than an optical projector (which achieves the same result). A pantograph is a simple tool that consists of a series of hinged levers. When the point of a pencil at one end of the pantograph is traced around the outline of a drawing, the pencil at the other end of the pantograph traces out the same outline, but on a larger or smaller scale, depending on how the pantograph has been set. If you are doing a lot of scale work, a pantograph will save a lot of time compared with the traditional method of using squared paper to enlarge or reduce a drawing.

Art knives By far the best implement for cutting paper and boards is the art knife. Art knives have separate blades that can be removed and changed when they lose their cutting edge. The blade itself is made from best quality steel that will stay sharp for a long time — there is no point in trying to sharpen a blunt knife blade because replacement blades are easy to fit.

Art knife blades are available in different shapes; the two most common shapes are those with a straight cutting edge and the curved variety. The straight blade has a sharp pointed tip that is useful for spearing small pieces of paper or mask, and also for getting under the edge of a piece of mask when you want to lift it up from the work.

It goes without saying that it is important to keep your knife well out of the way of accidental handling — try to put it back in a closed container such as a pencil box when you have used it, rather than having it lying around in a drawer where you might cut yourself on it while looking for some other piece of equipment.

Curves Certain kinds of airbrush work, particularly technical illustration, require the drawing of accurate circles, ellipses and other curves. There are various aids on the market to make it easy to draw curves.

French curves consist of plastic shapes of various sizes, each shape having an outline of curves of a different radius. By choosing the appropriate part of the outline, you should be able to draw the type of curve you require, either by holding the French curve against the work and using it as a template or by using it to draw the curve on a mask. There are also stencil templates that have a large number of different circles and ellipses cut into them. Most of the common sizes can be found in a set of these templates. Again, they can be used either as templates for spraying or as guides for mask cutting.

If the curve you need is unusually complex or of an uncommon size, you may need to use a flexible curve. This is a strip of flexible material that can be bent into almost any shape and will stay in that shape until it is bent again. Flexible curves have the added advantage that they can be molded against the shape you want to draw, then removed and transfered to the work to act as a template.

Lastly, there is the profile guide. This tool consists of a large number of fine teeth that slide inside a holder. When the ends of the row of teeth are pressed against a shape, they slide back, leaving the shape represented by the edge of the teeth. Profile guides are useful for transfering the shape you want to copy when you are making a mask. They are not suitable for use as templates for spraying because the edge of the shape will not be a smooth curve, being made up of a large number of small teeth.

If you spray a lot of different curved shapes in the course of your

A set of drawing instruments is essential for techical work. The basic kit (**left**) includes French curves (**1**), a flexible curve (**2**), and rulers (**3**) and (**4**). Technical pens (**5**) will draw lines of accurate width. An X-Acto knife (**6**) is ideal for cutting out, a divider (**7**) is useful for measuring and marking out.

work, it is worth building up your own reference library of outlines. One way to achieve this is to make an extra copy of each curve by spraying it on a piece of square paper and then noting on it the details of the job; then if you need to repeat the job you can go straight to your own reference rather than having to measure the curve again in order to make a mask.

Rulers Many kinds of airbrush work demand accurate measuring and cutting out of masks and templates. This is particularly true of technical illustration, where inaccuracies may destroy the whole point of the artwork. Nowadays, almost all technical artists work in metric measurements but it is still occasionally handy to be able to measure in inches — some kinds of nuts and bolts, for instance, are measured in imperial units.

A good-quality engineer's rule will be calibrated along both edges and some have calibrations on both edges of both sides. Such rules are made of steel and never wear out. The other advantage of steel rules is that you will not chip their edges when you are using them as a straight edge for cutting against. Wooden or plastic rulers inevitably get nicked by your scalpel and eventually become anything but straight.

If you are doing a lot of cutting of straight edges, it is worth buying the kind of ruler that is made of pressed steel with a raised portion along the center that has a recess for the fingers. This type of ruler is especially designed for safety because it keeps your fingers well out of the way of the cutting edge, making sure that they cannot slip off the ruler into the path of your knife.

Supports

An airbrush can spray color onto virtually any surface but most airbrushing for general artistic purposes is done on paper or board. Of the two, board is preferable because it remains flat when the paint dries. On the other hand, paper is a lot cheaper than board if you are just experimenting and is also lighter to transport if you need to carry a large portfolio.

Board You can buy artists' board, such as Colorcast board or Bristol board, in a variety of standard sizes. This board consists of a base of compressed pulp, which gives the board strength and stability, covered by a layer of good-quality art paper. The paper is kept flat by the stiffness of the base so, as long as you are fairly careful when handling the board, the finished artwork is unlikely to suffer from creasing or cracking. The smoothness of the surface of the artists' board is also an advantage for the airbrush artist. It makes it easier to lift off adhesive masking without lifting surface fibers, and masking films stick to the board closely without leaving any gaps for stray flecks of paint to get under.

Watercolor paper Other kinds of board are designed with watercolor painting in mind, such as the CS2, Fabriano, Arches or Strathmore ranges. They do not have the same smooth surface as artists' board and so masking may not be quite as effective and may tend to lift off the surface when it is peeled away. The softer nature of the surface also gives a less precisely defined quality to airbrush work done on it, making it less suitable for sharp, crisp artwork.

Paper For airbrushing purposes, paper has the disadvantage that it may wrinkle as it dries, and can stretch when masking films are lifted from it. These problems can be avoided to a large extent by stretching the paper across the drawing board or by sticking it onto a firm base, such as a piece of hardboard. One advantage of using paper, apart from the cost, is that you can choose from a much larger range of

colors, textures and sizes than is available with boards. Before beginning a piece of work on a piece of paper that has unknown qualities, it is always best to try out the colors and techniques you will be using, on a spare piece of paper, to see whether you are going to hit any snags such as stretching or excessive soaking of color around the area you have been spraying.

Acetate As an alternative to paper, clear acetate film has many attractions. One is that it is ideally suited to making cutaway artworks, such as those that show the anatomical layers inside the human body, each one revealed as each sheet is pulled back. Also, it is perfect for making artworks that might need to be seen against different backgrounds, as would be the case in making an animated cartoon. Similarly, a transparent background is suitable for window stickers and overhead projector slides, whether used singly or in multiple sets.

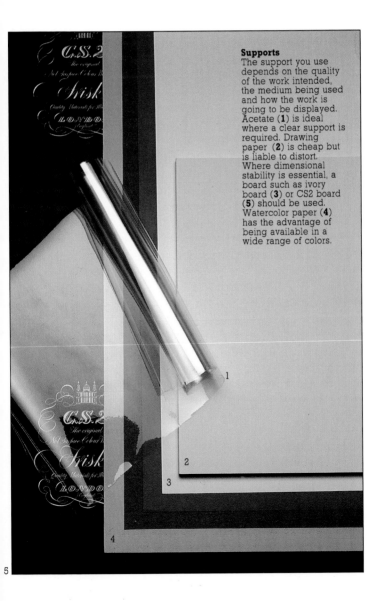

Supports
The support you use depends on the quality of the work intended, the medium being used and how the work is going to be displayed. Acetate (**1**) is ideal where a clear support is required. Drawing paper (**2**) is cheap but is liable to distort. Where dimensional stability is essential, a board such as ivory board (**3**) or CS2 board (**5**) should be used. Watercolor paper (**4**) has the advantage of being available in a wide range of colors.

USE, MEDIA AND SUITABILITY

The airbrushes on sale at present cater for every need, from detail spraying of small areas to painting large expanses. If you have a specific requirement, such as model making, you can buy an airbrush tailored to your own needs, which will take the right medium you require. However, if your airbrushing is more varied in nature,

USE	Badger 350-F	350-M	350-H	200 EX	100 GX
Photo retouching					●
General illustration				Flat colours only	●
Large backgrounds		Up to A3	Up to A2	●	
Model making	●	●	●	●	
Car customizing	●	●	●	●	
China restoration	Overall glaze only	Overall glaze only	Overall glaze only	Overall glaze only	●
Fine art painting	●	Large areas only	Large areas only	●	
Fabric painting	●	●	●	●	
MEDIA					
Liquid Dyes (Luma, Dr. Martins)	●	Large areas	Large areas	●	●
Artists' watercolors	●	Large areas	Large areas	●	●
Gouache	●	Medium area	Large areas	●	●
Acrylic colors				●	
Artists' oil colors				●	
Modelmaker's enamels	●	●	●	●	
Cellulose paint		With extreme care	With extreme care	●	
Car customizing acrylics		With extreme care	With extreme care	●	
Fabric colors	●	●	●	●	
Waterproof inks	●	Large areas	Large areas	●	●

there are several general-purpose airbrushes which can be used in a variety of situations with a large range of media. Pick the most suitable airbrushes from the chart and then ask to try them out in the shop to see if they have the indefinable quality of 'feel' which suits you.

100 XF	100 IL	100 LGXF	100 LGIL	100 LGHD	150 XF	150 IL
●		●			●	
●	●	●	●	●	●	●
				●		
		●		●		●
				●		
●	●	●	●	●	●	●
			●	●		●
				●		
●	●	●	●	●	●	●
●	●	●	●	●	●	●
●	●	●	●	●	●	●
				●		
				●		
		●		●		●
				●		
				●		
				●		
●	●	●	●	●	●	●

Use, Media and Suitability
Continued

USE	Badger 150 HD	400 Touch-up Gun	Conopois	De Vilbiss Super 63A	Super 6...
Photo retouching			●	●	●
General illustration	●		●	●	●
Large backgrounds	●	●			Up to A3
Model making	●	Large scale only		Only very small items	●
Car customizing	●	●			●
China restoration	●			With care	●
Fine art painting	●	●			●
Fabric painting	●	●			●
MEDIA					
Liquid Dyes (Luma, Dr. Martins)	●	●	●	●	●
Artists' watercolors	●	●	●	●	●
Gouache	●	●	●	●	●
Acrylic colors	●	●		With care	●
Artists' oil colors	●	●			●
Modelmakers' enamels	●	●			●
Cellulose paint	●	●			With care
Car customizing acrylics	●	●			With care
Fabric colors	●	●			●
Waterproof inks	●	●	With care	●	●

	Sprite	Sprite Major	MP C-C	MP 1-1	MP 2-2	MP 3-3	**Hohmi** Y3
	•		•				•
	Up to A3	Up to A2	•	•	•	•	•
	•	•	•	Large scale only	Large scale only	Large scale only	•
	•	•	•	•	•	•	
	•	Overall glaze only	•	Overall glaze only			•
	•	Large areas only	•	•	•	•	•
	•	•	•	•	•	•	•
	•	•	•	•	•	•	•
	•	•	•	•	•	•	•
	•	•	•	•	•	•	•
	•	•	•	•	•	•	•
	•	•	•	•	•	•	•
	•	•	•	•	•	•	•
	•	•	•	•	•	•	•
	•	•	•	•	•	•	
	•	•	•	•	•	•	•
	•	•	•	•	•	•	•

Use, Media and Suitability
Continued

USE	Iwata	HP-A	HP-B	HP-C	E-1	E-2
Photo retouching	●	●	●			
General illustration	●	●	●	●	●	●
Large backgrounds					●	●
Model making				●	●	●
Car customizing						●
China restoration				●	●	●
Fine art painting				●		●
Fabric painting				●		
MEDIA						
Liquid Dyes (Luma, Dr. Martins)	●	●	●	●	●	●
Artists' watercolors	●	●	●	●	●	●
Gouache	With care	●	●	●	●	●
Acrylic colors				With care	●	●
Artists' oil colors				With care	●	●
Modelmakers' enamels				With care	●	●
Cellulose paint					●	●
Car customizing acrylics					●	●
Fabric colors					●	●
Waterproof inks	With care	●	●	●	●	●

SB	BC	BE-1	BE-2	Olympos HP-100A	HP-100B	HP-100C
				•	•	
•	•	•	•	•	•	•
	•	•	•			
•	•	•	•		•	•
•	•	•	•			
•	•	•	•			•
•	•	•	•			•
•	•	•	•			
•	•	•	•	•	•	•
•	•	•	•	•	•	•
With care	With care	•	•	With care	•	•
•	•	•	•			With care
•	•	•	•			With care
•	•	•	•			
•	•	•	•			
•	•	•	•			
•	•	•	•			
•	•	•	•	With care	With care	•

Use, Media and Suitability
Continued

USE	Olympos SP-A	SP-B	SP-C	Paasche F-1	H-1
Photo retouching	●	●			
General illustration	●	●	●		
Large backgrounds					
Model making		●	●	●	●
Car customizing					●
China restoration			●	Overall glaze only	Overall glaze only
Fine art painting			●		●
Fabric painting					●
MEDIA					
Liquid Dyes (Luma, Dr.Martins)	●	●	●	●	●
Artists' watercolors	●	●	●	●	●
Gouache	With care	●	●	●	●
Acrylic colors			With care		
Artists' oil colors			With care		
Modelmakers' enamels				●	●
Cellulose paint					With care
Car customizing acrylics					With care
Fabric colors					●
Waterproof inks	With care	With care	●	●	●

	H-3	H-5	VJR	V-1	VLS-1	VLS-3	VLS-5
			•	•			
			•	•	•	•	•
	Up to A3	Up to A2					•
	•	•			•	•	•
	•	•			•	•	•
	Overall glaze only	Overall glaze only			•	•	•
	•	•			•	•	•
	•	•			•	•	•
	Large areas	Large areas	•	•	•	•	•
	•	•	•	•	•	•	•
	•	•	•	•	•	•	•
					•	•	•
					•	•	•
	•	•			•	•	•
	With care	With care					•
	With care	With care					•
	•	•			•	•	•
	Large areas	Large areas	•	•	•	•	•

Use, Media and Suitability
Continued

USE	Paasche AB Turbo	Rich AB-100	AB-200	AB-300
Photo retouching	•	•	•	
General illustration	•	•	•	•
Large backgrounds				
Model making				•
Car customizing				
China restoration			•	•
Fine art painting				•
Fabric painting				
MEDIA				
Liquid Dyes (Luma, Dr. Martins)	•	•	•	•
Artists' watercolors	•	•	•	•
Gouache		With care	•	•
Acrylic colors				•
Artists' oil colors				•
Modelmakers' enamels				•
Cellulose paint				
Car customizing acrylics				
Fabric colors				•
Waterproof inks		With care	•	•

Thayer & Chandler Model A	Model AA	Model C	Model E	Model G
•	•			
•	•	•	•	•
		•	•	•
		•	•	•
		•	•	•
	•	•	•	•
		•	•	
		•	•	•
•	•	•	•	•
•	•	•	•	•
With care	With care	•	•	•
		•	•	•
		•	•	•
		•	•	•
		•	•	•
		•	•	•
		•	•	•
With care	•	•	•	•

7
GLOSSARY

This glossary contains terms used frequently in airbrushing and in servicing airbrushes. Cross-references to entries that occur elsewhere in the glossary are indicated in CAPITALS

Abrasives Usually in the form of metal polish, they remove any corrosion that may build up on the components, and which may prevent the airbrush from running smoothly.

Absorbency The property of any material to soak up liquid or moisture.

Acetate A matte or gloss plastic film, which is transparent and available in varying thicknesses. It is used as a surface in ANIMATION work, or for OVERLAYS, or shapes can be cut out of it for stencils.

Acrylic Paints made from a synthetic resin. They can usually be diluted with water, although in some cases a special diluent is needed. They have the great advantage of drying quickly to form a plastic coating which is very hard-wearing as well as water-resistant.

Adapter This enables the airbrush artist to connect any type of AIR HOSE to any airbrush.

Additive colors In photographic reproduction these are the PRIMARY COLORS of light — red, green and blue — that are mixed to form all other colors.

Aerosol lubricant An extremely handy aid which not only keeps the springs of the airbrush lubricated but acts as a penetrating oil to free stubborn nuts and screws when dismantling is necessary.

Against the grain When the paper is marked or folded at right-angles to the grain.

Air A term used to describe the large areas of white space in a layout.

Airbrush There is evidence that 35,000 years ago Aurignacian man used airpainting on the walls of his caves, blowing paint through the hollow leg bone of a deer. However, in 1893 Charles Burdick invented the first airbrush as we know it. It is a mechanical painting tool which is propelled by compressed air. The air mixes with the paint and the two combine to form a fine spray on the painting surface. The airbrush consists of a fine internal needle, a nozzle where the air and paint are mixed, a receptacle to hold the color, and a pen-shaped body. This is connected by a hose to the propelling device. (See DOUBLE-ACTION FIXED; DOUBLE-ACTION INDEPENDENT; EXTERNAL ATOMIZATION; FELT-TIP FED; GRAVITY FEED; INTERNAL ATOMIZATION; PAASCHE TURBO; SINGLE-ACTION FIXED; SIPHON FEED).

Airbrush holder A holder which keeps the airbrush in a horizontal position while it is not being used, so that the color does not run out of the COLOR CUP.

Air cans These are cans of compressed air which can be used instead of a COMPRESSOR, but for regular use they are expensive. However, the advantage of air cans is that they are easily portable.

Air eraser More subtle in effect than normal methods of erasing, the air eraser is based on the same principle as an airbrush except that fine particles of an abrasive material are propelled onto areas to be corrected. It can also be used for special shading effects and engraving glass.

Air hose The hose that connects the airbrush to the air supply; usually made from rubber covered with cotton or nylon braid.

Air pump The part of the COMPRESSOR that compresses the air and forces it into the AIR HOSE and through the airbrush.

Air trap See MOISTURE TRAP.

Air valve The assembly that is fitted into the body of the airbrush, above the AIR HOSE connection. It is operated by the TRIGGER and controls the air flow.

Album paper Paper made from wood pulp with an antique finish, which is usually used for the pages of photograph albums.

Albumen plate A plate used in lithographic reproduction which was originally coated with albumen to create a photosensitive surface.

Alignment The arrangement of material to bring it into line and level with a set horizontal or vertical line.

Anaglyph When two pictures of one image are superimposed in complementary colors and viewed through glasses with corresponding color

filters, one for each lens.

Angle of view See VIEWPOINT.

Aniline The oily liquid obtained from coal tar that is used in the production of dyes and aniline printing ink.

Animal-sized Term used to describe paper that is sized by passing it through a bath of animal glue or gelatin. See SIZE.

Animation A technique used in film to create movement by the rapid projection of a series of gradually varying drawings of the same subject.

Annotation The notes or labels added to an illustration.

Anodized plate An offset printing plate treated specifically to harden the surface, which prevents it wearing down in the press.

Antiquarian The biggest size of handmade paper, 53 x 31in.

Antique paper A lightly-sized paper with a rough finish, used mainly for books and folders.

Aquatint The method used to reproduce even or graded tones in INTAGLIO printing.

Art paper Paper coated with a china clay compound which produces a hard smooth surface.

Artwork Illustrations or designs which are of a standard good enough for reproduction. Also known as CAMERA-READY artwork.

Assembled view A term used in technical drawing which shows an object made up of various components as a whole.

Automatic compressor The most advanced type of COMPRESSOR. It delivers air into a reservoir until it reaches a pre-set pressure, then shuts itself off. As the airbrush is running and the pressure gradually drops below a certain level in the reservoir, the motor cuts in again to refill the reservoir automatically.

A/W The abbreviation used for artwork.

Axis The imaginary center hose around which an object rotates or, on a flat plane, the line that divides a regular object symmetrically.

Background The part of an illustration or design that is farthest from the viewer and onto which the main subject is superimposed.

Back up When a sheet of paper is printed on both sides.

Balance The harmony of proportion and color in the images of an illustration or design.

Bank paper A light uncoated paper used for making carbon copies.

Bar A unit of atmospheric pressure.

Barium sulfate A white metallic filler used with china clay to coat paper. Also known as BLANC FIXE.

Baryta paper Paper that has a special coating of BARIUM SULFATE gelatin to make it suitable for use on typesetting machines.

Base artwork Artwork that requires specific additions, such as OVERLAYS, before reproduction.

Base material A support made from any type of material which can be coated or plated.

Base stock The stock of various materials that is built up to make different types of papers.

Basic size The standard size of a specific paper from which any other size is cut.

Bastard The term used to describe a paper or type which does not conform to a standard size.

Benday prints In lithographic reproduction and blockmaking, these are a series of mechanical tints in the form of celluloid sheets, used when texture, shading and detail have to be added to line drawings.

Bible paper An opaque paper which is very thin, but tough, and used for printing bible text on.

Billboard A large-scale outdoor sign or poster mainly used in advertising.

Bimetal plate A plate with a copper printing area and aluminum or steel non-printing areas, that is used in lithography for long runs.

Binder A liquid medium which, when mixed with powder pigment, forms paint. It also fixes the properties of certain paints.

Blad A booklet which contains sample pages of a book, produced for promotional purposes.

Blanc fixe See BARIUM SULFATE.

Bleed (1) When using colors that have to be overlaid, great care must be taken because certain pigments stain. When these colors are covered by another color they will always show, or 'bleed', through. **(2)** The area of an illustration that extends beyond the CROPMARK.

Block in To prepare for an illustration or design by first sketching in the main areas and points of an image.

Blocking out See MASK.

Blow up To make a photographic enlargement of an image.

Bond paper Paper with an even finish that is used for typing and printing.

Book paper The description of any type of paper that is suitable for book printing.

Border Ruled lines or a decorative design that run around the outside of an image.

Box, box rule An image that is ruled off on all four sides with a heavy rule or border.

Bristol board A type of fine board available in a variety of thicknesses and qualities with a smooth finish, and suitable for airbrushing.

Bromide A coated photographic paper with a smooth finish, which is also suitable for airbrushing.

Bronzing A method used to produce a metallic effect by applying powder to a sheet treated with special printing ink.

Brushwork Usually the final stage of an airbrush painting in which fine detail or special effects are added by hand, using a hair paintbrush.

Bubble A circle used to enclose an enlarged detail in a technical drawing, or the speech in a cartoon.

Bulk The thickness of a sheet of paper related to its weight.

Calender The column of metal rollers that paper passes through under pressure in the final stage of paper-making, which closes the pores and smooths the surface.

Caliper (1) The measurement used when referring to the thickness of a paper or board, expressed as thousandths of an inch (mils) or millionths of a meter (microns). **(2)** The name of the instrument that measures such a thickness.

Calligraphy The term used to describe the specialized art of fine hand lettering, which is derived from the Greek word **kalligraphia,** meaning beautiful writing.

Camera ready Ready for reproduction. See ARTWORK.

Canvas board A board suitable for ACRYLIC or OIL PAINT with a simulated canvas texture.

Caption The block of words that accompanies and describes an illustration or picture.

Carbonic gas cylinders These cylinders are sometimes used as a source of air. They are available in a range of sizes and although you have to buy the first cylinder, from then on you can exchange the empty cylinder for a full one and pay for the gas only. A pressure REGULATOR has to be used because the pressure in a fully-charged cylinder is far too high for an airbrush to handle.

Cardboard A thick paper produced in various colors which is used mainly for display graphics.

Caricature A drawing that exaggerates and distorts the features of the chosen image for a comic or satirical purpose.

Cartridge paper An all-purpose drawing paper with a rough surface.

Car tires A cheap and basic alternative to a compressor, which can be reused a number of times.

Casein Used as an adhesive in the manufacture of coated papers and as a BINDER for certain paints. It is a protein obtained from curdled milk.

Cast-coated paper An exceptionally glossy art paper, with an enamel finish.

Cel An acetate sheet used in animation. One cel represents every small change in a sequence of movement. Airbrushing can be done directly onto these sheets.

Cellophane A very thin and flexible, transparent acetate film.

Cellulose acetate A transparent or translucent plastic sheet material available in different colors, with a matte or shiny finish. Most commonly used for OVERLAYS and certain artworks.

CFM Abbreviation of cubic feet per minute, used to describe the output of air from a COMPRESSOR.

Chain lines Lines that are made by the wires of a papermaking machine and visible running through laid paper.

Chemical pulp Wood pulp which is processed for the manufacture of high-quality printing paper.

Chroma The purity or intensity of a color.

Chromo Paper that is heavily coated on one side and used for printing.

Chromograph A machine that reproduces plans etc., by using aniline dye instead of ink.

Chromolithography The use of several colors in lithography.

Circular screen A photographic screen used in color reproduction that can be adjusted to prevent the occurrence of MOIRÉ patterns.

Clean proof A printer's proof without any errors.

Coated paper The general term for all art papers where a mineral coating is applied after the body paper is made.

Cold pressed A category for a specific type of paper surface. It refers to the way in which sheets of paper are laid on top of each other without felts, and consequently become slightly compressed, creating a medium-smooth texture.

Collotype A photomechanical printing process where the image is printed from a raised gelatin film on a glass support, giving continuous tone which enables fine detail to be reproduced.

Color break The edge between two areas of color in an image.

Color cast board A fine art board which is coated with a very hard, smooth finish. Its paper surface can be stripped from the board.

Color circle This is a graphic representation of the relationship between primary and secondary colors as well as successive color mixtures and tonal values.

Color coder An instrument used to compare the intensity of printed colors, to insure correct reproduction.

Color cup The receptacle that is attached to the airbrush and holds the paint.

Color separation To reproduce a continuous

tone or multicolored artwork, the colors are divided into basic portions by a process of photographic filtration. Each of these portions are reproduced by a separate printing plate carrying the designated color.

Color value The TONAL VALUE, or density, of a color as compared to a light-to-dark scale of pure grays.

Commercial art This describes artwork that is used for advertising or promotion as opposed to fine art.

Composite artwork A piece of artwork which combines a number of different elements.

Compressed air aerosol An air spray that is very useful for blowing away specks of dirt, especially from inaccessible passages inside an airbrush.

Compressor The most common piece of equipment used to propel an airbrush. It has a motor which maintains an air supply at a certain air pressure. (See AUTOMATIC COMPRESSOR; DIAPHRAGM COMPRESSOR; DIRECT COMPRESSOR; PISTON COMPRESSOR; STORAGE COMPRESSOR; TANK COMPRESSOR.)

Continuous tone When the image in a colored original contains continuous shades between the lightest and darkest tones, without being broken up by dots.

Controlling dimension The measurement of either the height or width of an image on which the amount of

enlargement or reduction is based.

Cool colors An expression used to describe blue and green or any other colors with a blue or green cast.

Copperplate printing A process used for short runs in INTAGLIO printing which produces a very black but sharp image.

Copyright The right to reproduce or make copies of. See UNIVERSAL COPYRIGHT CONVENTION.

Correction overlay A sheet of tracing paper loosely attached to the artwork on which any corrections are indicated.

Counter-mark A WATERMARK which holds the initials of the papermaker, placed opposite the normal watermark.

Crash finish The name given to paper with a coarse linen-like finish.

Cropmark Short lines at each corner of the paper that indicate where the artwork can be trimmed.

Cross-section A view of an object that has been cut through to illustrate its internal structure or characteristics.

Crown A standard size of printing paper 15 x 20in.

Curl A measurement which applies to papers that are used in wet or damp processes. It is the height to which the edges of the paper will curl.

Curved plate A plate

which curves around the plate cylinder of a rotary press.

Curves Made of plastic or metal, these templates are produced specifically for techical drawings (See ELLIPSES; FLEXIBLE CURVES; FRENCH CURVES.)

Cut-away This describes a method in technical illustrations of showing the internal components of a complicated mechanism such as an engine, by cutting away a portion of the outer casing. In the finished illustration the cut sections are shown in red.

Cyan The shade of blue used in the FOUR-COLOR reproduction process.

D

Deckle edge The rough, uneven edge of handmade paper.

Deep-etching When unwanted material is removed from a halftone plate, by etching, to give a white background.

Delineate To accentuate outlines in line artwork by making them heavier.

Demy A standard size of printing paper $17^1/2$ x $22^1/2$in.

Density The measure of tonal values in a printed image.

Diaphragm compressor This design of COMPRESSOR includes a diaphragm which is made to oscillate by the motor. As the diaphragm moves in one direction the air is

sucked in and then pumped through the air hose when the diaphragm moves back. This action causes pulsing in the air flow, which is noticeable in delicate airbrush work.

Diploma paper A fine paper which is produced especially for printing certificates, official documents or any matter of this nature.

Direct image master/ plate A paper plate used for short runs in lithography, on which the image can be drawn directly.

Display board A heavy, coated board with a dull finish; available in various colors.

Distance guide A device that fastens to the airbrush and has an adjustable arm which fixes the distance between the airbrush and the surface that you are spraying.

Divider A stiffly-hinged instrument with two points, used for transfering dimensions from a rough sketch to final artwork.

Double-action fixed A type of airbrush where the lever controls the flow of paint and air, but not the ratio of one to the other.

Double-action independent This airbrush gives the artist the greatest flexibility. A lever controls the flow of air and paint individually, therefore allowing the ratio of one to the other to be altered.

Double-coated paper A heavily coated paper coated on one or both sides.

Drafting machine A drawing instrument which combines a T-SQUARE, STRAIGHT-EDGE, SET SQUARE and PROTRACTOR.

Driers Metallic salts used to accelerate the drying of ink.

Drop shadow A shadow painted just behind an image to bring it forward visually.

Dry mounting A process used mainly to smooth out wrinkled paper, or reinforce artwork. A sheet of tissue impregnated with heat-sensitive adhesive is placed between a sheet of board and the paper, then pressed under force with heat.

Dry transfer lettering Letters on a plastic sheet that are transfered onto a surface by rubbing the back of the sheet gently to release the letters.

Dull finish Another way of describing paper with a matte finish.

Duplex board/paper Board or paper that consists of two types of sheets pasted together which gives a different color or surface quality on each side.

Duplicate An identical copy of an original.

Dutch paper Deckle-edged paper produced in the Netherlands.

Dye-based ink Ink that gains its color from aniline dye.

Edition The complete number of copies printed and issued of a single work at one time.

Eggshell finish Drawing paper with a rough finish.

Eight sheet A poster size measuring 60 x 80in.

Elevation A drawing of a piece of equipment or machinery, or an architectural structure, which shows a vertical projection of the structure.

Ellipse A regular oval corresponding to an oblique view of a circular plane.

Enamel paper See COATED PAPER.

Engine sizing A way of sizing paper by adding emulsified resin to cleaned paper pulp. See SIZE.

Esparto A long, rough grass with soft fibers, grown in Spain and North Africa, which is used for making paper.

Etching (1) A metal plate on which the printing images are treated with acid while the non-printing areas are masked by the application of a ground. **(2)** The print taken from such a plate.

Exploded view An illustration of an object with its component parts shown separately, but arranged in such a way as to indicate their relationships within the object when assembled.

External atomization The most basic airbrush, where the mixing of the air and paint takes place outside the body, which results in an uneven spray.

F.A.D. Abbreviation of free air delivered. This term refers to the volume of air actually delivered by the COMPRESSOR, usually 70% of the quoted volume of displaced air.

Fadeback A technique used to fade color away gradually. See GHOSTING.

Fashion board Body boards lined with rag paper on one side and thin paper on the other to prevent warping.

Featherweight paper A paper, preferably with a high ESPARTO content, which is bulky but light, and rarely calendered.

Felt finish A finish applied to the paper by felt while in the manufacturing machine.

Felt side The printing or top side of paper.

Felting The stage in papermaking when the fibers in the wet pulp are bound together.

Felt-tip fed airbrush A simple design which, instead of using paint, draws its color from a large felt-tip pen fitted in the airbrush. It produces rather crude results, but makes it easy to change color.

Fiber A threadlike, cellulose plant cell that provides the basic element of papermaking material.

Figure title The name or title given to an illustration, as opposed to a caption.

Film Transparent celluloid. See CELLULOSE ACETATE.

Fine rule A very fine line. See HAIRLINE RULE.

Finish Refers to the surface applied to paper during its manufacture.

Finished artwork Artwork ready for reproduction. See ARTWORK; CAMERA READY.

Finished rough See PRESENTATION VISUAL.

Finisher An illustrator who adds the color or finishes to artwork that has already been drawn by another artist.

Fixative A clear solution that is sprayed over artwork without altering the colors. When dry it acts as a protective coating and prevents the color from smudging.

Flexography The reproduction of an image in letterpress printing from rubber or flexible plates.

Flimsy A type of BOND PAPER that is semi-transparent and used mainly for LAYOUTS.

Flow line A line used to indicate the relationship of components in an object which are drawn separately, as in an EXPLODED VIEW.

Fluorescent ink Colored ink that is luminous, due to its phosphorous content. It can be either natural or synthetic.

Foolscap Standard size of printing paper $13\frac{1}{2}$ x 17in.

Foreshorten To show in an illustration the illusion of an image receding, due to visual perspective.

Forty-eight sheet A standard poster size measuring 120 x 480in.

Four-color process A method of reproducing a full-color image by color separation, from which four plates are made for printing in CYAN, yellow, MAGENTA and black.

Freehand The application of an airbrush without masking of any kind.

French curves A set of plastic shapes in various sizes where the edge of each is a curve in a different radius.

French folio A smooth, thin, sized paper.

Flexible curve A flexible strip especially useful for complex curves because it can be bent into almost any shape and stay that way until bent again.

Frisk film A proprietary brand of masking film.

Frisket An early form of masking film, where rubber solution was applied to a thin translucent paper.

Fugitive colors Colors that are not permanent and fade in natural light.

Ghosting A technique used in technical illustration, showing the internal view of a mechanism covered by its casing, which is represented by a thin veil of color. To achieve the ghosted image the casing would be airbrushed to make it look transparent.

Glassine A paper that

is grease-resistant and translucent.

Gloss ink A printing ink with a synthetic resin base and containing drying oils. These inks are suitable for use on coated papers because they dry quickly, without penetration.

Gouache A form of watercolor in which the pigment has precipitated chalk added to it before being bound with gum arabic. It is water-soluble, opaque and available in a wide range of colors.

Gradation The subtle transition from one color or tone through to another.

Grain The pattern of the FIBERS in manufactured paper.

Grain direction The direction that the FIBERS run through a sheet of paper.

Graphic design Illustration or design involving two-dimensional processes.

Gravity feed This type of airbrush has the color cup mounted on top of it which means that the cup has to be smaller than SIPHON FEED designs. But due to their lighter weight they are more maneuverable and therefore more controllable for very accurate work.

Gravure An abbreviation of PHOTOGRAVURE.

Greases Lubricants that enable you to keep the airbrush running smoothly. There are a number of greases available such as HMP (high melting point) grease and a copper-based grease.

Grid A useful measuring guide to help assess the relative size of the parts of an image by plotting the key points and transfering them onto the support. Also used to alter scale by transfering the key points onto a correspondingly larger or smaller grid.

Ground The thin coating that protects the non-image area of an etching plate from the action of the acid, which is made from pitch, gum-mastic, asphaltum and beeswax.

Groundwood A cheap wood pulp used to make newsprint.

Gum arabic A water-soluble gum obtained from the sap of acacia trees. It is used with inks, watercolors and pastels to give extra body and sheen.

Hairline rule The thinnest line possible to reproduce.

Halftone A printing process which simulates continuous tone by a pattern of dots of varying size from a zinc or copper plate.

Half-up The size of an artwork when it is one-and-a-half times the size at which it will be reproduced.

Hard-edged A technique of airbrushing which produces sharp edges by means of hard masking.

Hard masking A masking material that adheres to the surface

of the artwork so that it will produce a clean, sharp line.

Hard size A paper containing the maximum amount of SIZE.

High gloss ink A glutinous ink that is not absorbed by paper and dries to a glossy surface.

Highlights These are the lightest areas of an artwork. They are created by spraying white over an opaque medium or, when a transparent medium is being used, by masking the unpainted areas until the final stage.

HMP See GREASES.

Hot Pressed Manufactured paper that is glazed by the heated metal plates of a roller system.

Hue The attributable quality of a pure color.

Illustration An image that is drawn as opposed to photographed.

Image This refers to the subject that is to be reproduced by the artist.

Image area The amount of space which is designated for a specific image.

Imperial A size of paper, 22 x 30in.

India paper An opaque paper made from rags which is very fine but strong and used for printing bibles and dictionaries.

Ink A liquid medium

which holds pigments in suspension. The two main types of inks are waterproof and non-waterproof. Both are ideal for airbrushing but the range of colors is limited.

Ink drier A chemical agent to speed drying and prevent smudging when added to ink.

Intaglio A printing process in which the image area is recessed below the surface of the plate.

Internal atomization The mixing of paint and air inside the nozzle of an airbrush, which produces an even spray.

International paper sizes A range of paper sizes standardized by the ISO. The papers are designated series A, B and C and are available in proportional sizes, divided into ratio to the largest sheet.

Internegative A photographic negative of the artwork from which certain plates are produced.

ISO The International Standards Organization — based in Switzerland and responsible for standardizing many elements common to design, photography and publishing.

Ivory board A good-quality white board with a smooth finish which is used for artwork.

Jointing compound A jelly-like substance used to achieve an airtight seal between closely fitting parts.

Key The block of plate in color printing which holds the main outlines of the image. This acts as a guide for the position and registration of the other colors.

Keyline An outline drawing showing the size and position of an illustration of halftone image.

Knifing A method of removing unwanted areas of paint from the surface by gently scratching with an art knife or razor blade. This technique can also be used to create HIGHLIGHTS.

Knock back To reduce the overall tonal contrast. This can be done, for example, by spraying white gouache over an artwork. This is also used when a feeling of distance is required, by softening the background color.

Laid paper Manufactured paper which shows the wire marks of the mold.

Laminate To apply a transparent plastic coating to an illustration or artwork by heat or pressure, giving it permanent protection.

Landscape format The shape of an image when it is greater in width than in height.

Lateral reversal To transpose an image from left to right, as in a mirror image.

Layout A sheet which shows how a printed page will look by indicating the position of the text and illustrations.

Letraset Proprietary brand of DRY TRANSFER LETTERING.

Letterhead The name, address and telephone number of a business or individual which is printed onto stationery.

Letterpress A printing process in which the image area is raised and inked for reproduction.

Light box A box with a translucent glass top that is illuminated by lights fitted inside the box. Mainly used for viewing or working with photographically produced material such as transparencies.

Lightfast ink Ink that does not fade when exposed to light.

Line board A support suitable for line illustrations and artwork with a smooth finish.

Line weight A term used to describe the thickness of a line or rule used in illustration.

Liquid mask A liquid rubber compound that is painted onto a surface and dries on contact to form a MASK. When spraying is complete it can be peeled or rubbed away.

Lithography A printing process in which the image is reproduced from a dampened flat surface using greasy ink, based on the principle of the mutual repulsion of oil and water.

Logo/Logotype Letters, or a word, cast as one unit. Commercial companies often have

their own specific logo which is used as the company identity.

Loose masks Any kind of mask that is not stuck to the surface.

Machine-glazed paper Paper that is machine-finished with a high gloss surface on one side.

Magenta The established shade of red used in the FOUR-COLOR PROCESS.

Manila A paper used in the manufacture of stationery, which is buff-colored and tough.

Mask Anything that is used to prevent the spray from reaching the surface. (See FRISKET; FRISK FILM; HARD MASKING; LIQUID MASKING; LOOSE MASKING; MASKING FILM; MASKING TAPE; SOFT MASKING; STENCIL; TORN PAPER MASK).

Masking film This is the most widely used mask. It has a self-adhesive backing, and is transparent so that the mask can be cut in position on the surface to be sprayed.

Masking tape A self-adhesive tape that can be laid in straight lines for hard-edged airbrushing, or a curve can be formed by stretching the outside edge as you stick it down.

Master plate The plate that holds an image for offset printing.

Matte art Paper that is clay-coated with a dull finish.

Matting and flapping A way of presenting artwork which involves matting the work on board and protecting the surface with a hinged sheet.

Matting board A heavy board used for matting artwork.

Mechanical pulp Untreated paper pulp used in low-quality paper and newsprint.

Medium (1) A term that refers to any kind of paint, dye or coloring agent that is used to color a surface. Most media can be used with an airbrush as long as they are mixed to the right consistency.
(2) A substance added to a paint to alter it in some way — to thicken it, dilute it or make it dry faster.

Metallic ink Ink that produces the same metallic quality as metals like gold, silver, copper or bronze.

Mezzotint A method of INTAGLIO printing that produces a range of tones.

Mock-up A rough visualization of an idea, that indicates its size, color and composition, etc.

Moiré A fault in printing where halftones appear as a mechanical pattern of dots.

Moisture trap A unit fitted between a compressor and an airbrush to prevent the build-up of condensation that is the cause of blotting and uneven paint flow.

Monochrome An image made up from varying tones of one color.

Monogram A design formed from the initials of a name.

Montage The combination of elements from several different images to create a single new composition.

Mordant A fluid used to etch a printing plate.

Moldmade paper A paper manufactured to appear as if it has been handmade.

Mouth diffuser The most basic of all spraying tools. It consists of two hollow tubes that are hinged together at right-angles. Air is blown through the upper, horizontal tube and causes paint to be drawn in the vertical tube which is placed in a jar of paint. The paint mixes with the air, and produces a colored spray.

Multisheet drawing An artwork that requires more than one drawing to create the image as a whole.

Munsell color system The system that defines colors in terms of HUE, TONAL VALUE and CHROMA.

Needle As well as controlling the flow of the medium, the accuracy of the spray depends on this important component of the airbrush.

Needle packing gaskets Fitted inside the body of the airbrush, these gaskets enable the needle to move smoothly, yet prevent the paint from being forced back into the handle.

Newsprint An unsized, and therefore absorbent, paper used for newspapers.

Nozzle The tapered casing in which the air and paint are mixed and the needle contained.

Offset lithography A lithographic process in which reproduction is not made directly from the plate but 'offset' first onto a rubber-covered cylinder which performs the printing.

Oil·paint A thick medium that has to be diluted for use with an airbrush. It is available in an almost unlimited range of colors but takes a long time to dry.

One-and-a-half up The size of an artwork when it is one-and-a-half times the reproduced size. See HALF-UP.

One-third reduction The amount of reduction (66%) necessary with artwork prepared at HALF-UP.

Onion skin Paper that is thin and translucent, with a glazed finish, used often for OVERLAYS.

Opaline A fine, semi-opaque paper with a highly glazed finish.

Original The artwork from which reproductions are made.

'O' ring The washer at the base of the nozzle. It is tiny, circular and made of rubber.

Overlay (1) Any sheet of translucent paper covering an artwork on which instructions are written.

(2) For certain methods of reproduction a multicolor artwork will consist of several overlays each indicating a different color.

Paasche Turbo This company which has been producing airbrushes for years has introduced a new idea where the compressed air flows through a turbine. It looks completely different from any other airbrush and, although complicated, the system allows the artist far greater control.

Pantograph A simple tool consisting of a series of hinged levers with a pencil at each end. As you trace around the outline with the pencil at one end, the pencil at the other end reproduces the same image on any scale depending on how the levers are set.

Pantone matching system A registered trade name for an extensive color matching system that runs through the complete range of designer's materials.

Pastel A coloring medium in the form of sticks that are made from powdered pigment bound in glue and allowed to harden.

Perspective Any drawing technique that creates the impression of three dimensions on a flat surface from a fixed point or points of view.

Perspective grid A grid printed with two or three vanishing points to aid the construction of technical drawings.

Photodirect A method of producing plates for photolithography directly from the artwork rather than from an internegative.

Photogravure A method of printing from a photomechanically prepared surface, which holds the ink in recessed cells.

Photolithography A lithographic printing process in which the image is transfered to the plate photographically.

Photomechanical transfer A quick method of producing photoprints from flat originals.

Picking When small scraps of the paper surface are lifted during printing due to tacky ink or poor-quality paper.

Pigment Solid matter ground very finely which forms the coloring agent of paints.

Piston compressor In this design of COMPRESSOR the electric motor drives a piston that compresses the air.

Plastic film A general term for materials used for lamination, such as cellophane, with varying qualities of transparency and thickness.

Plate A sheet of metal that holds the image to be reproduced.

Plot To mark the main points of reference on a grid.

Poster A large-scale display used widely for advertising. See BILLBOARD.

Presentation visual An initial drawing of the proposed appearance of the final artwork.

Primary colors The three pure colors from which all other colors are mixed.

Process white An opaque white gouache used mainly for corection and masking.

Profile guide This device consists of a number of teeth which slide into a holder. When the teeth are pressed against the shape to be copied, they slide back, leaving the edge of the teeth to reproduce the shape.

Projection A way of showing a three-dimensional object, line or figure from a given viewpoint. See ELEVATION.

Propellant Any source that provides the air to power an airbrush.

Proportional scale A scale used to increase or reduce proportionally the size of a piece of artwork.

Protractor A circular or semi-circular instrument for measuring angles.

p.s.i. Pounds per square inch. A measurement of the pressure output of COMPRESSORS, which refers to the surface air pressure above atmospheric pressure.

Pulsing The irregular airflow from a COMPRESSOR that does not have a reservoir tank.

Quad Four times the normal paper size — 35 x 45in.

Quick-disconnect coupling A miniature joint at each end of the AIR HOSE that automatically shuts off the air when it is disconnected.

Quire Twenty four sheets of paper.

Rag paper Paper of a high quality made from rag pulp.

Ream Five hundred sheets of paper.

Reamer needle A special needle with a flat plane on the taper which is used to clean the NOZZLE of an airbrush.

Regulator An accessory for a COMPRESSOR which enables the artist to control the air pressure to create different effects. It also acts as a MOISTURE TRAP.

Relief printing Any printing process in which the image is reproduced from a raised surface.

Render To reproduce an image.

Reproduction copy See CAMERA READY.

Reservoir (1) A component in some COMPRESSORS that supplies the airbrush with air. It is a sealed steel chamber built to withstand high pressure and is fed directly from the air pump.
(2) Another term for the color cup or paint well of an airbrush.

Resist A method of combining drawing and watercolor painting. Designs are drawn with wax crayon or oil pastel so that when a wash of water-based paint is laid over them, they remain visible in their original color, while the areas of bare paper accept the wash.

Retouching The alteration or correction of mistakes in an existing image in an artwork or photograph.

Return spring This component is responsible for the smooth return of the needle when the trigger is released.

Reverse out To reproduce lettering or line illustration as a white image on a solid or halftone background.

Rotary press A press in which the paper is fed from a continuous roll and has a cylindrical printing surface. Newspapers are printed by this method which also delivers them counted and folded.

Rough A preliminary sketch showing the color and composition of an image. See MOCK-UP.

Royal A size of printing paper 20 x 25in.

Ruler A drawing implement made from a straight strip of wood, plastic or metal. It is printed with accurate measurements in inches and centimeters, which are useful for technical illustrations.

Satin finish Paper with a smooth finish and sheen to the surface.

Save out See REVERSE OUT.

Scale drawing A technical drawing or illustration such as a map, that represents the subject in direct proportions.

Scale To ascertain the amount of enlargement or reduction necessary to reproduce an image in a given area. The scaling will be in direct proportion to or represent a percentage of the image, which is achieved by using a diagonal bisection of the image.

Scamp A very basic, quick rough sketch representing the idea for a design or illustration. See ROUGH.

Screenprint A printing technique where the ink is forced through a fine screen to which a stencil has been applied. The airbrush is used when photographic stencils are used.

Scribing The technique of correcting or altering an image which is on film or a metal plate by scratching the surface.

Secondary colors The colors that are obtained from mixing two primary colors.

Separation artwork Artwork for reproduction which is made up from a series of separate OVERLAYS, each one representing an individual color.

Set square A drawing aid made from a flat piece of plastic or metal in the shape of a right-angled triangle.

Shadow The darkest tones and areas of an artwork. The opposite of a HIGHLIGHT.

Sheet A single piece of paper.

Silhouette An outline drawing of an image which is filled with solid color or tone.

Silkscreen printing The same as SCREENPRINTING, except that the screen is made of silk.

Single-action fixed A type of airbrush in which there is no control over the pattern of spray or the ratio of paint to air.

Siphon feed In this design of airbrush the color cup is attached to the underside of the airbrush. This means that the cup can be much bigger than if it were fixed to the upper side of the airbrush, which makes it suitable for spraying large areas. See GRAVITY FEED.

Sixteen sheet A standard poster size measuring 120 x 80in.

Size A gelatinous solution used to coat and seal the surface of a support making it less porous when the medium is applied.

Size up See SCALE.

Soft-edged An effect in airbrushing which is achieved by LOOSE MASKING, where the spray drifts so there are no clearly defined outlines.

Soft masking The use of any mask that is not applied directly to the surface.

Solvents Substances used to remove solidified color from the passages of an airbrush. Methyl hydrate is the most commonly used solvent, but brake fluid might be necessary for very stubborn cases.

Spatter A technique used in airbrushing which produces a textured, grainy effect, created by increasing the flow of paint and decreasing the flow of air.

Spatter cap An accessory for the airbrush that replaces the nozzle cap to give a spattered spray.

Spotting A method of RETOUCHING, used to cover blemishes on a photographic print.

Spray The fine mist of paint and air emitted from the airbrush onto the painting surface.

Spray gun A spraying tool similar to an airbrush but much less delicate in the results it produces.

Starburst highlight A star-shaped highlight created with an airbrush to suggest a high sheen.

Stencil A piece of card or other material that has shapes cut out of it for use as a mask.

Stipple A method of airbrushing which employs small dots to give tone and texture to a flat surface.

Stipple cap A type of SPATTER CAP which produces spattering in fine, controllable lines.

Storage compressor A COMPRESSOR that has a reservoir tank for the compressed air, eliminating any PULSING that may occur.

Straight-edge A drawing implement usually made from steel or plastic, with long straight edges.

Strawboard A

manufactured board with a rough finish, which is made from straw pulp.

Stripping When two or more images are assembled, producing a composite or multiple image for photomechanical reproduction.

Subject See IMAGE.

Subtractive color mixing When colors are reproduced by over-printing PRIMARY colors in different relative densities, thus gradually subtracting the reflection of light from the white of the paper.

Supercalendered paper Paper with a smooth surface that is produced by rolling it between metal rollers, or CALENDERS.

Support A term applied to any material which provides the surface for a drawing or painting.

Swatch A small piece of paper on which a sample of a specific color tone is shown.

Symmetrical An image in which one half is the mirror image of the other.

T-square A drawing implement that is a STRAIGHT-EDGE with the addition of a cross bar at one end. The bar is aligned to the edge of the drawing board, thus providing an accurate rule for parallel lines.

Tack A term that refers to the adhesive quality of a medium.

Tank compressor A very large type of COMPRESSOR which has a moisture trap and reservoir.

Technical illustration A specialist type of illustration depicting mechanical objects or systems and their components.

Technical pens Pens that have very fine nibs which are in the form of tubes with an ink reservoir, so that when the pen is held at right-angles to the paper it creates a line of constant width. The nibs are interchangeable and come in a variety of sizes. The two proprietary brands are Rapidograph and Rotring.

Template A ready-made sheet with cut-out shapes and designs used for drawing or cutting masks.

Thirty two sheet A poster size measuring 120 x 160in.

Tight A term used to describe an image which is small and detailed, with clear definition, leaving very little white space exposed.

Tint (1) A color made lighter by the admixture of white.
(2) A color lightened by breaking it up into dots which allow the white paper to show through.

Tonal value The density of tones in an image. See also COLOR VALUE.

Tooth The surface texture of the paper that enables it to hold the medium.

Torn paper mask A mask which is made from any piece of paper that is torn as opposed to cut. The uneven, ragged edge creates a broken, fuzzy line which is useful, for example, for suggesting reflections.

Tracing paper Translucent paper which, when placed over an image, reveals the image clearly, enabling the artist to draw the outline of the image accurately.

Trammel method A method in which the major and minor axes of an ellipse are marked onto a strip of paper which is moved about an axis to establish a series of points that are connected to form an ellipse of any size.

Transfer To convey an image from one surface to another.

Translucent Materials that transmit light but are not totally transparent.

Transparency Any image on a transparent base made visible by light behind it, although usually it refers to a photographically developed positive image in color.

Trigger The external part of the airbrush which is operated by the artist to set the airbrush into action.

Trim marks The marks on a printed sheet which indicate where to cut the paper to the required size.

Twice-up An artwork completed to twice the size at which it will be reproduced.

Underlay A color, tone or effect which is laid in

underneath the image or artwork.

Universal Copyright Convention An international assembly which in 1952 agreed to protect the originator of a design or illustration against their material being reproduced without previous permission being granted. The work must carry the copyright mark and the name of the individual or organization that holds the copyright and the date of publication.

Vanishing point The point at which receding parallel lines viewed in perspective appear to converge.

Varnish A transparent solution sprayed over an artwork which produces a glossy, protective finish.

Viewpoint The angle at which an image is represented to provide the best analytical or esthetic study.

Vignette A small illustration that is not contained within a border.

Visual See FINISHED ROUGH and PRESENTATION VISUAL.

Watercolor A transparent color medium that is diluted with water and is very

suitable for airbrush use.

Watercolor paper Paper manufactured specifically for watercolor, which does not wrinkle when wet. This paper does not have a smooth surface but possesses a soft quality which makes it unsuitable for precise work.

Watermark A design that is incorporated into the paper during manufacture.

Woodfree Paper manufactured from totally chemical pulp.

Wove paper Paper manufactured on a roll of fine, closely-woven wire which leaves no marks on the surface of the paper.

List of Addresses